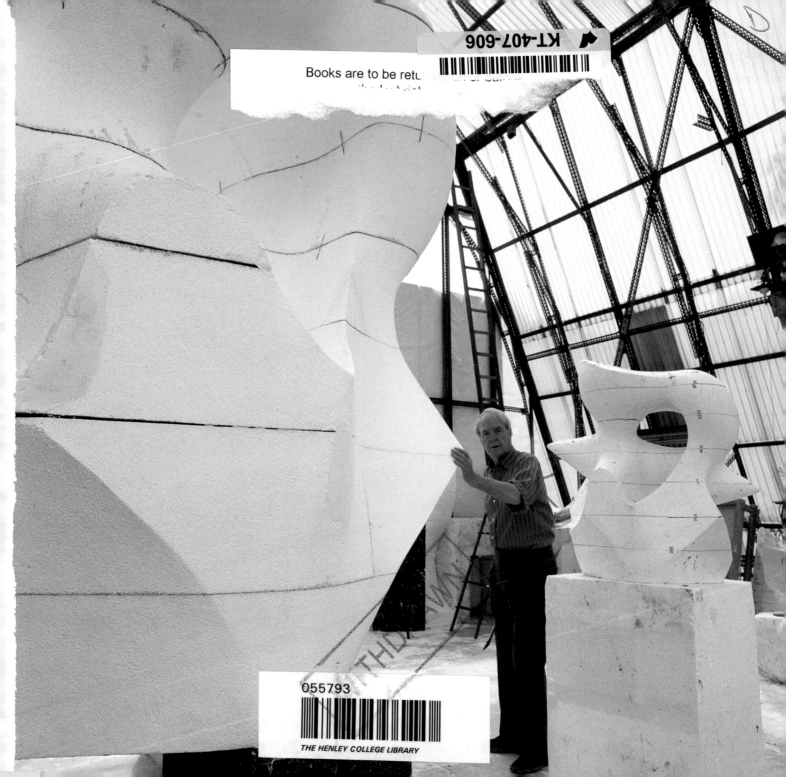

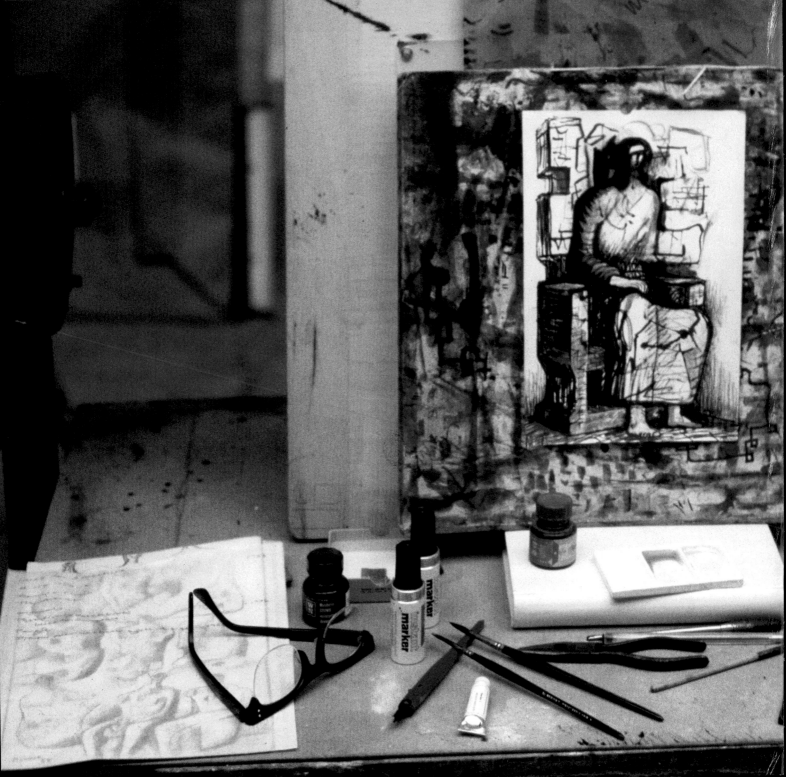

HENRY MOORE
AT PERRY GREEN

The Henry Moore
Foundation

SCALA

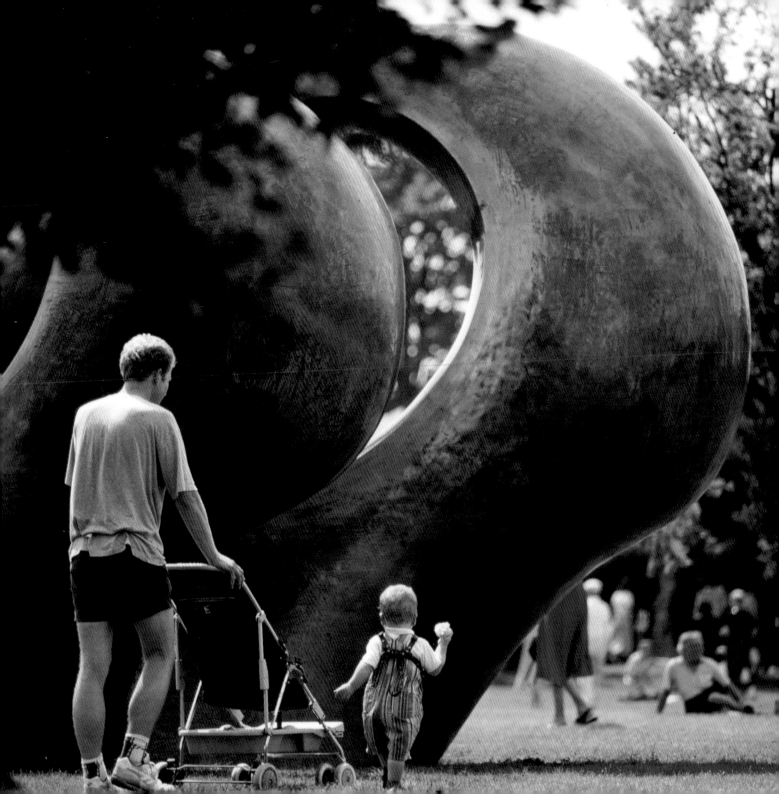

CONTENTS

page 1 Henry Moore working on the enlargement of *Large Spindle Piece* (1974) in the Plastic Studio at Perry Green.

frontispiece Moore's paints, brushes and inks.

left Visitors in the grounds at Perry Green in 1998 with *Double Oval* (1966).

FOREWORD

It gives me great pleasure to welcome you to Perry Green, the former home of Henry Moore for nearly half a century and, since 1977, the headquarters of The Henry Moore Foundation. I hope you enjoy the unique experience of visiting the house where Moore and his family lived; the various studios where he created his extraordinary sculptures, prints and drawings; the grounds where he sited his larger bronzes in the natural environment he preferred; and the annual exhibition of his work in the Sheep Field Barn gallery.

Moore was one of the greatest sculptors of the twentieth century who believed passionately that the visual arts, and especially sculpture, should be widely accessible. As well as opening Perry Green to the public for over half of every year, the Foundation funds a research institute for the study of sculpture, named after Moore, in Leeds, close to his birthplace in West Yorkshire; and gives grants totalling approximately £1 million annually to arts organisations in the United Kingdom and abroad.

I first came to Perry Green in 1980 when I was a young curator at the Tate Gallery who had been given the job of cataloguing Henry Moore's recent gift of 35 of his sculptures. It was a dark winter's afternoon and I remember getting hopelessly lost in the labyrinth of lanes and narrow roads around Perry Green. When I eventually arrived at Hoglands, seriously late for my appointment, Moore – then well over 80 – could not have been more welcoming and offered me a cup of tea. Although he was a rich and famous artist, there was nothing grand or pretentious about him. We sat in front of the fire and talked about his work, as well as the wider subject of public sculpture, about which, to my surprise, he had certain reservations. It was a fascinating couple of hours. I shall never forget his kindness to me as I started my career in the art world.

Richard Calvocoressi
Director, The Henry Moore Foundation

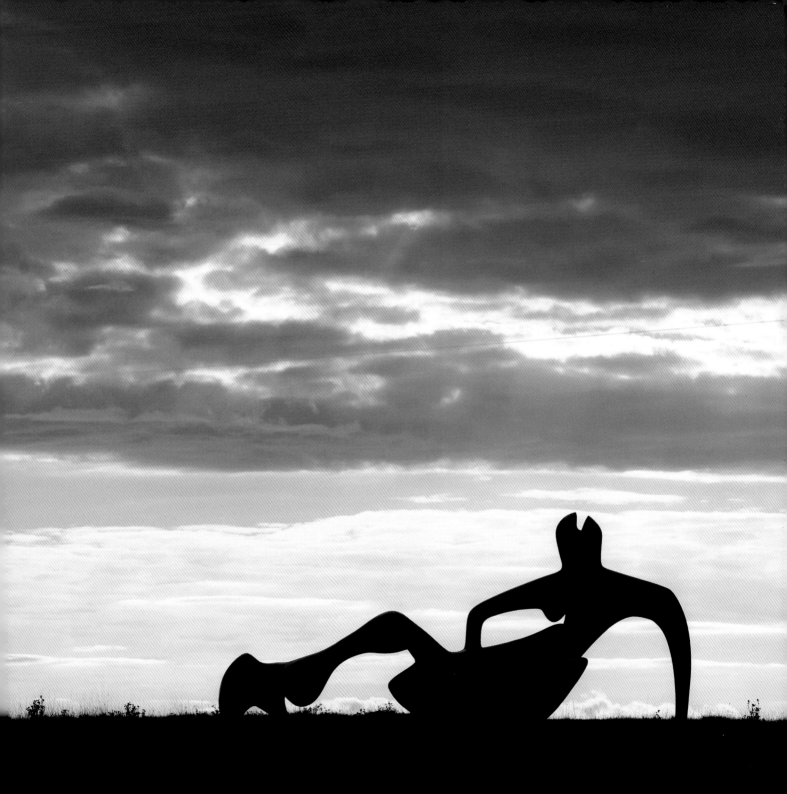

HENRY MOORE AT PERRY GREEN

Moore landscaped the small hill on which this work, *Large Reclining Figure* (1984), is sited. At the opposite end of the estate from the village green, the sculpture can be viewed from a considerable distance, across fields, silhouetted against the sky.

Henry Moore always welcomed visitors to Perry Green. During his lifetime, he considered steps to establish an organisation that would safeguard not only his artistic legacy, but also the unique experience of visiting his home and studios. This came to fruition in 1977 with the establishment of The Henry Moore Foundation. Speaking in 1975 about his plans for the Foundation, Moore observed that he would like the atmosphere of a working studio to be retained so that visitors would feel that they were 'seeing the whole place as though the sculptor is still active'.

The Henry Moore Foundation was established with the aim of conserving the work and the reputation of the artist, and the setting in which that work was created, as well as to assist in the promotion of the arts, especially sculpture. This remains the core of its rationale today. The Foundation is a charity funded entirely through its own resources and is a major grant-giving body to the arts. The Foundation was initially regulated by a board of Trustees selected from Moore's family and friends. Thereafter, until the end of his life, Moore effectively became an employee. The business side – administrative work, cataloguing, photography, sales and the complex planning of exhibitions – initially took place in the small office in Hoglands, but in 1976 a neighbouring house, The Poplars, came up for sale and was soon acquired. Renamed Dane Tree House by Moore, this became the headquarters of the Foundation.

The Foundation owns a large collection of sculpture, drawings and graphics by Moore, much of which was donated by the artist in 1977. Other works were acquired subsequently by gift or purchase, with the aim of making the collection more fully representative. The collection consists of approximately 800 sculptures in stone, wood, plaster or bronze; 3,000

Large Standing Figure: Knife Edge (1976), *Reclining Figure: Hand* (1979) and *Three Piece Sculpture: Vertebrae* (1968). The placing of sculptures of different types and periods in sight of each other offers visitors the chance to explore themes and connections in Moore's work as they walk around the grounds. There are usually between 25 and 30 sculptures displayed outdoors in any one season.

drawings (including sketchbooks); some 8,000 graphics (including states and proofs); and an important holding of tapestries and textiles. As such, it is one of the largest and most comprehensive single-artist collections in the world, requiring a small on-site team of curators and conservators to care for, display and interpret it.

The estate at Perry Green comprises over 70 acres of land, with Moore's sculptures sited across the grounds. In order to make the gardens and parkland more attractive as a background to the work, some careful planting has taken place to define boundaries, replace trees lost to disease or storm and hide unsightly buildings. As the estate and its surrounding countryside show influences going back to Saxon times, care has been taken to ensure that what remains of the ancient landscape is preserved, including new planting of native trees such as ash, hornbeam, field maple and oak. On the more domestic side, the two orchards have been replanted and extended, and the lawns are maintained to a height of grass suitable for the sculptures placed on them. Moore's studios, scattered through the grounds, remain as they were during his lifetime, presenting a microcosm of his working methods and practices.

The Moores' family home, Hoglands, remained in the Moore family until it was acquired by the Foundation in 2004. Following major building work during 2005–06, the ground-floor rooms of the house were reinstated to appear as they had been in the early 1970s, a time when the Moores' alterations to the house were complete and their collections of art and ethnography fully formed. In readiness for the refurbishment, over 4,000 objects were cleaned, photographed and carefully recorded; furniture was restored, fabrics rewoven or reprinted

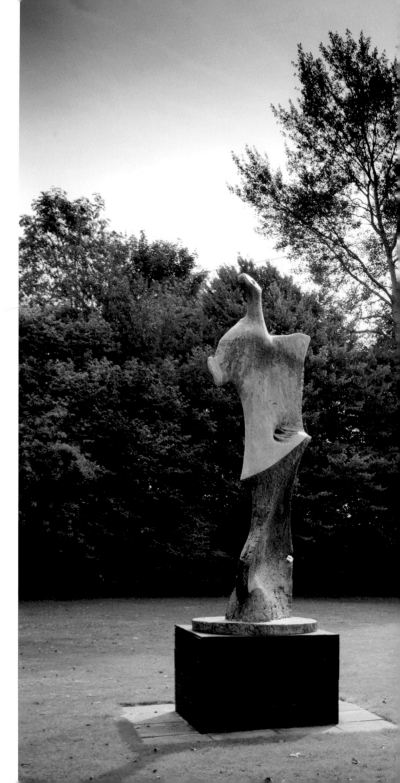

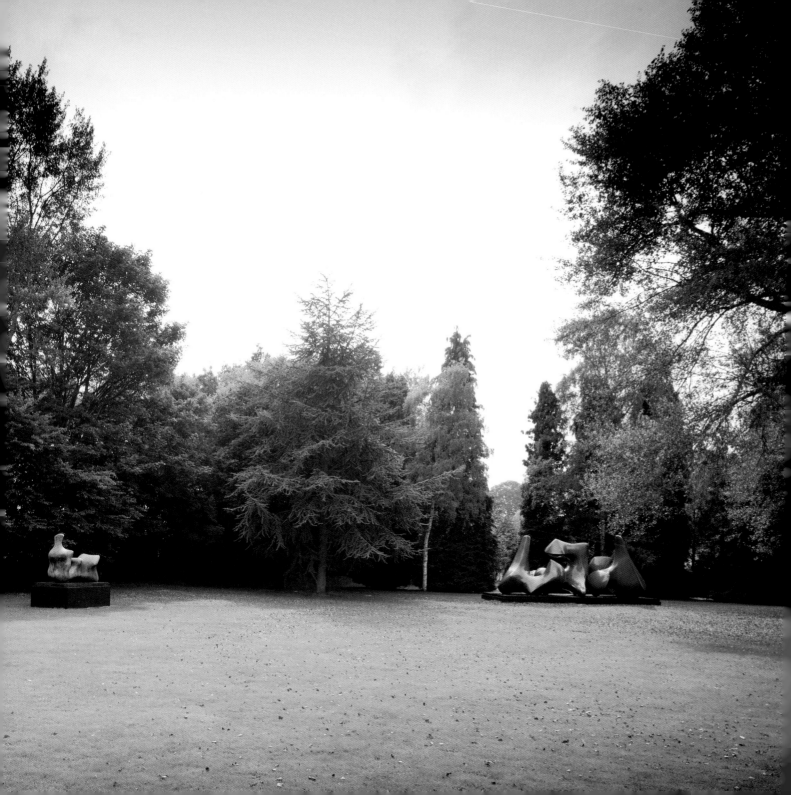

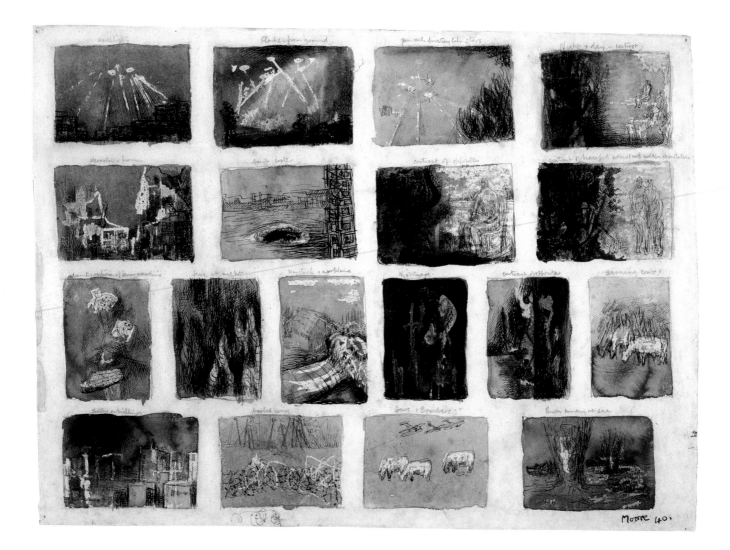

above *Eighteen Ideas for War Drawings* (1940). German bombing in the Second World War provided Moore with extraordinary sights that he recorded in sketchbooks, some of which are in the Foundation's collection. His most famous war drawings show people sheltering from the Blitz in the London Underground during 1940–41. Several of these drawings were acquired by the War Artists' Advisory Committee, headed by Kenneth Clark, director of the National Gallery at the time and a champion of Moore's work.

right The White Studio at Perry Green in 1996. Prominent in this view are, among other plasters, the working model for *Large Spindle Piece* (1974) and *Warrior with Shield* (1953–54) – minus its shield – the first in a series of sculptures Moore made on this theme in the 1950s. It was cast in an edition of five bronzes, one of which was controversially acquired in 1955 by Birmingham Museum and Art Gallery.

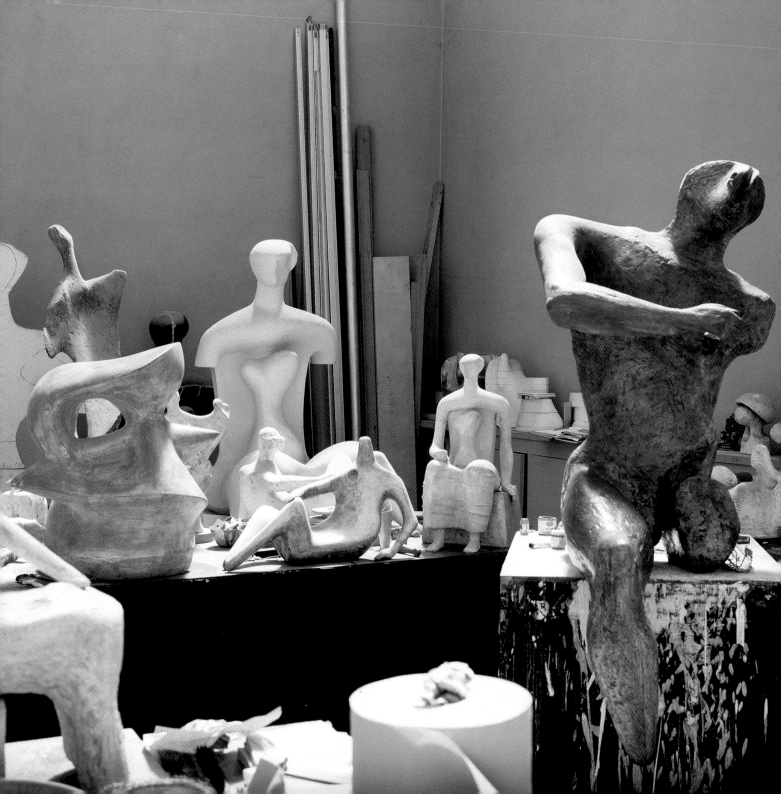

right A group of Moore's elmwood reclining figures in the *Henry Moore* exhibition at Tate Britain, London, 2010. The exhibition was seen by nearly 170,000 visitors.

below right Examples from the image archive at Perry Green. The Foundation owns a large collection of material relating to Moore's life and work, including correspondence, press cuttings, photographs, tapes, books and catalogues.

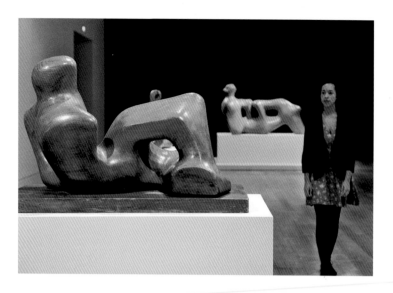

and art works conserved. The restored rooms now house over 50 works by Moore from the Foundation's collection and 25 art items on loan from the Henry Moore Family Collection, including significant paintings and ethnographic objects. In addition to the house, the adjacent Top Studio and Etching Studio were returned to use, and the greenhouses and surrounding garden restored and replanted. All of these were opened to the public in 2007.

As part of its directive, the Foundation is actively involved in curating, mounting and supporting exhibitions both at Perry Green and worldwide. Between 2008 and 2011, over 20 large outdoor sculptures toured to three cities in the USA, while in 2010 a landmark Moore exhibition at Tate Britain was seen by nearly 170,000 people before travelling on to Toronto, Canada and back to Leeds, Yorkshire.

When Moore established the Foundation at Perry Green in 1977, his vision was not only to create an organisation that would care for a very large collection of his sculptures and works in other media, but to ensure that these were accessible to the public, situated within the vibrant context in which he lived and worked. The gradual purchase of land and buildings over Moore's lifetime, which had begun with just a few sheds and a narrow garden at Hoglands, resulted in the estate we see today. It is home to one of the largest permanent displays of Moore's outdoor sculptures, as well as indoor displays dedicated to his tapestries and textiles, and annual thematic exhibitions showcasing rarely seen works from the Foundation's collection.

The estate at Perry Green includes several purpose-built exhibition spaces. In 1980, under Moore's guidance, the timbers

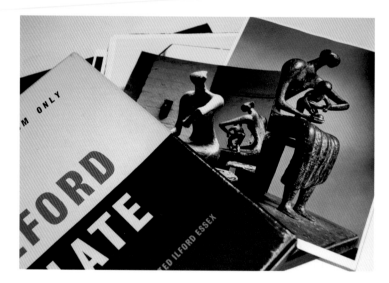

right On entering the Aisled Barn, the visitor leaves behind the play of light that enlivens the outdoor sculptures, and enters a world of measured calm. This view shows three of the tapestries woven by West Dean College in Sussex (the Edward James Foundation) based on drawings by Moore.

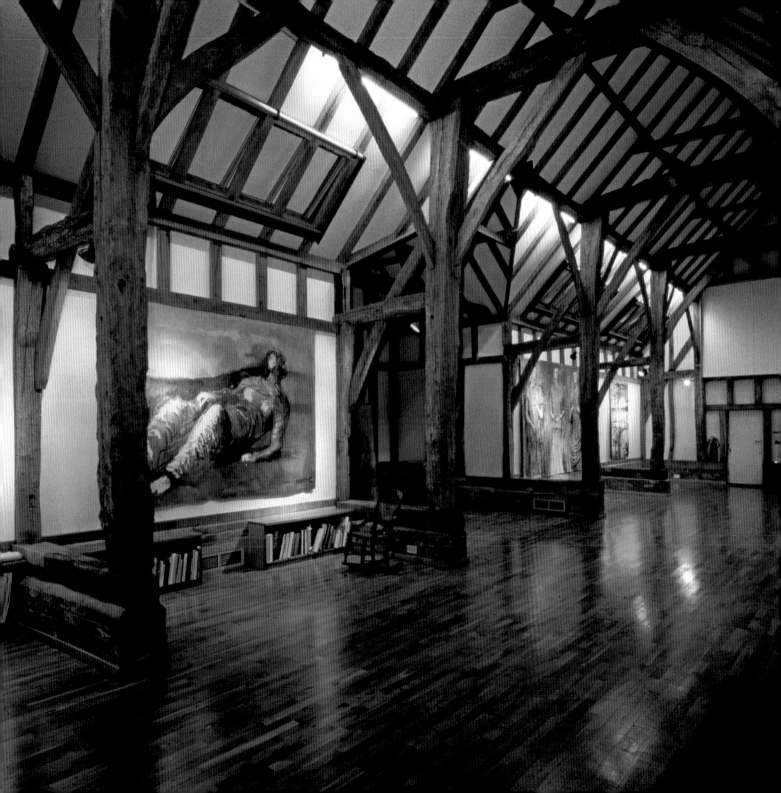

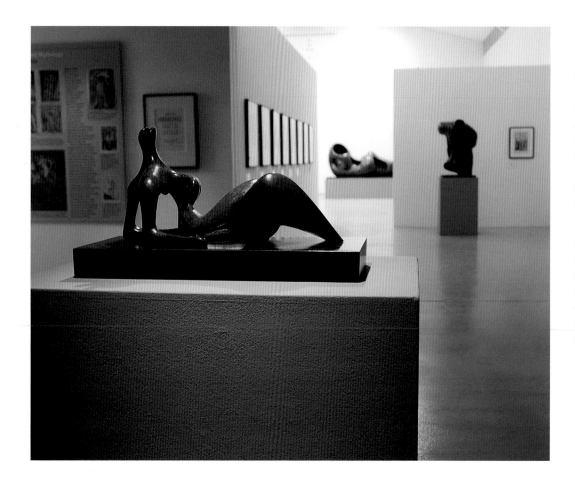

left The Sheep Field Barn gallery is home to annual thematic displays of Moore's work drawn largely from the Foundation's collection. These exhibitions frequently tour to other venues. *Henry Moore Textiles* (2008), for example, which revealed a little-known aspect of Moore's practice, was subsequently seen in Edinburgh, Chichester and Norwich.

right *Oval with Points* (1968–70) installed at the Atlanta Botanical Gardens in 2009, as part of the travelling exhibition *Moore in America*. The Foundation collaborates with institutions throughout the world in showing and interpreting Moore's work.

of a late medieval barn were re-erected at Perry Green by local craftsmen. Since then, the Aisled Barn has provided a setting to show tapestries based on Moore's drawings, which were woven at West Dean College, Sussex, between 1980 and 1986. These tapestries are complemented by occasionally changing small exhibitions from the Foundation's collection. The Sheep Field Barn gallery, converted from an agricultural building in 1999, provides space for annual thematic exhibitions.

Situated across the road from Hoglands is another building that now forms part of the Foundation's estate – The Hoops Inn. Following an extensive restoration project, it was reopened in late 2010. While further improvements will be made to visitor facilities over the coming years, the Foundation is confident that the rural and domestic character of Perry Green will remain essentially as it was in Moore's lifetime.

Academic awareness of Moore's work is encouraged through scholarship, research, conferences and publications. All archive material – consisting of photographs, correspondence, video and audio tapes, exhibition and sales catalogues, books and press cuttings dealing with Moore's life and work – is available by appointment for serious research. In 2010, the Foundation funded a curatorial post at Tate Britain to give Moore's work greater prominence in the national collection through contextual displays and research.

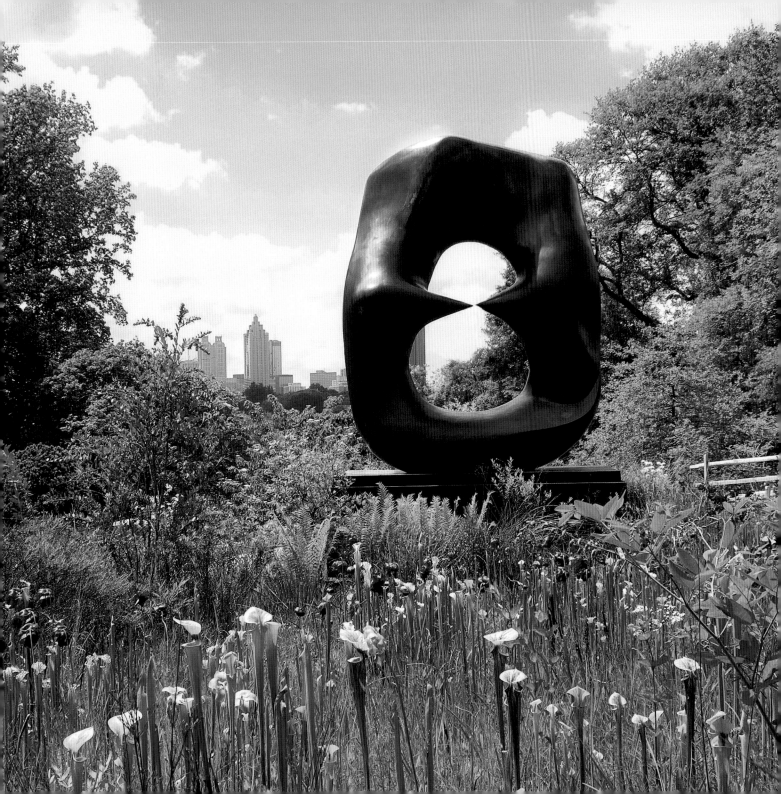

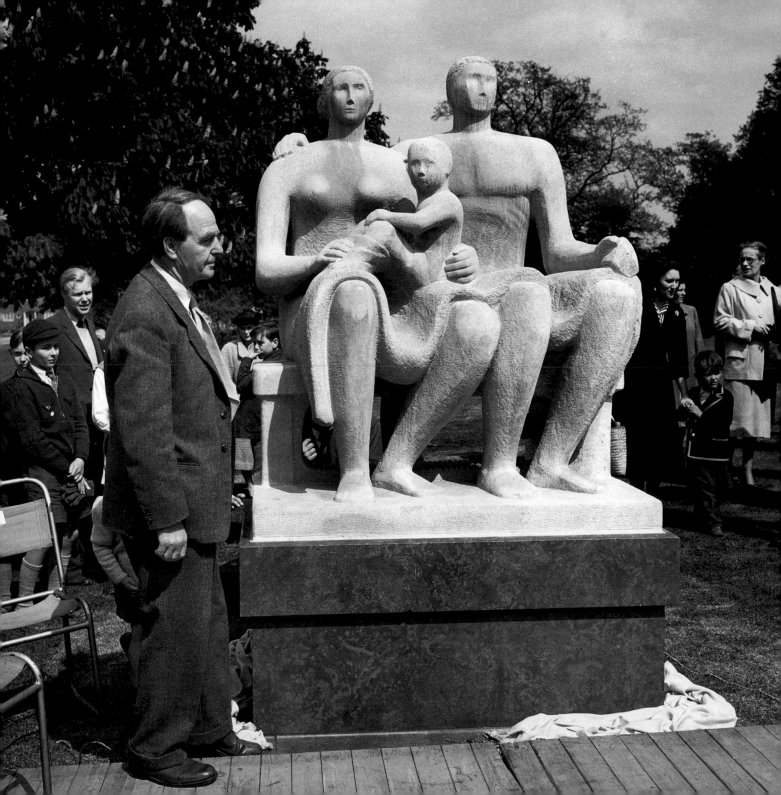

HENRY MOORE
A LIFE

Henry Moore is one of the twentieth century's most celebrated artists. Renowned for his powerful and often monumental forms, he is recognised as one of the key figures to have redefined British sculpture in the modern period. He also dedicated much of his career to increasing understanding and enjoyment of the arts, particularly sculpture. Born in Castleford, Yorkshire, where his father was a miner, the young Moore's passion for the art form that would inspire his life and work was ignited at primary school on hearing a story about the great sculptor, Michelangelo. Moore's education continued at the Leeds School of Art, where a sculpture department was set up to accommodate him: he was the sole student. Later, Moore won a scholarship to the Royal College of Art in London to study sculpture, and he went on to teach sculpture there and at Chelsea School of Art before leaving to pursue his already blossoming career as an artist. Major public commissions, exhibitions and awards followed, including the International Sculpture prize at the Venice Biennale in 1948, and retrospectives at the Tate Gallery in 1951, 1968 and 1978. His sculptures have been exhibited worldwide, including major tours in the United States, South America, Russia and China. Moore spoke eloquently about his work and ideas. He once remarked that 'all good art demands an effort from the observer' but that the observer, in turn, should 'demand that it extends his experiences of life'. Following his death in 1986, Moore left behind one of the most diverse single-artist collections, encompassing drawings, graphics, textiles and sculpture in different mediums.

Moore at the unveiling of *Harlow Family Group* (1954–55), Harlow New Town, Essex, May 1956. Moore's friend Frederick Gibberd, architect of Harlow New Town, decribed Moore's stone carving as symbolising 'the quality of life in Harlow'. The sculpture was later moved to a more protected site in the new Civic Centre building.

30 July 1898 Henry Spencer Moore is born, the seventh of eight children, in Castleford, Yorkshire.

1910 Wins a scholarship to Castleford Secondary (later Grammar) School. His first artistic influence is the art teacher Alice Gostick, who introduces him to contemporary European art.

1917 Enlists in the Civil Service Rifles, 15th London Regiment; is gassed at the Battle of Cambrai and returns to England to convalesce.

1919–20 Enrols at Leeds School of Art, where a sculpture department is set up with Moore as the sole student. Attends pottery classes in Castleford run by Alice Gostick.

1921 Wins a scholarship to the Royal College of Art, London, to study sculpture. Begins frequent visits to the British Museum, where he makes copious notes and sketches.

1924 Takes part in his first group exhibition at the Redfern Gallery, London. Takes up a seven-year appointment at the Royal College of Art. Rents work space at 3 Grove Studios, Hammersmith.

1928 His first one-man exhibition is held at the Warren Gallery, London; drawings bought by Jacob Epstein and Augustus John. Meets Irina Radetsky, a painting student at the Royal College of Art.

Moore (back row, far left) with 15th London Regiment, Civil Service Rifles, 1918.

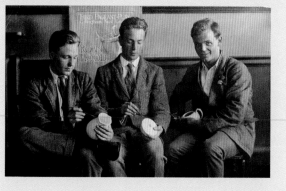

Moore at Alice Gostick's pottery class, with friends Raymond Coxon (centre) and Arthur Dalby (right), c.1919.

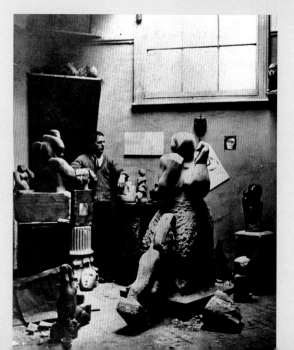

Moore in his first studio at 3 Grove Studios, Hammersmith, London, c.1927.

1929 Moore and Irina are married; they move to Hampstead, a centre for artists and writers in the 1930s. Completes *West Wind*, a relief sculpture on the north façade of the Headquarters of the London Underground, St James's.

1931 Resigns from his teaching post at the Royal College of Art. Becomes first head of sculpture in new department at Chelsea School of Art, a post he holds until 1939. Buys a cottage at Barfreston in East Kent.

1933 Joins Unit One, a group of English avant-garde artists. In Paris he meets the sculptors Alberto Giacometti, Ossip Zadkine and Jacques Lipchitz.

1935 Moves from Barfreston to Kingston, near Canterbury, and sites his sculpture outdoors.

1936 Participates in *International Surrealist Exhibition*, New Burlington Galleries, London.

1936–37 Trip to Paris to visit Picasso's studio; sees *Guernica* in progress.

1940 Henry and Irina move to Perry Green, Hertfordshire, when their London home and studio is damaged by bombs. Moore begins *Shelter* drawings of figures in the London Underground

1941 His first retrospective exhibition, with Graham Sutherland and John Piper, is held at Temple Newsam House, Leeds.

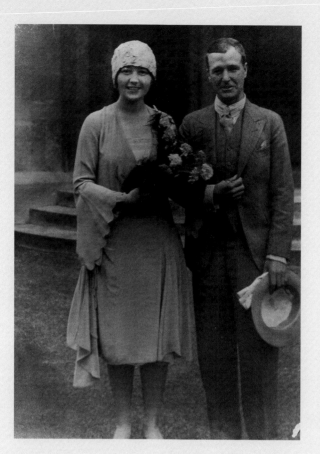

Henry Moore and Irina Radetsky on their wedding day in 1929.

Moore with Graham Sutherland (left) and John Piper (second left) beside *Reclining Woman* (1930) at their group exhibition, Temple Newsam House, Leeds, 1941. Kenneth Clark is on the right.

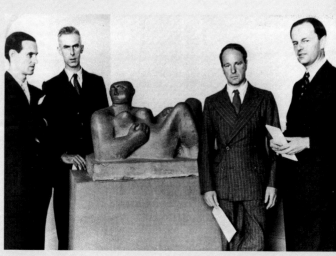

Moore is appointed a Trustee of the Tate Gallery, a position he holds intermittently until 1956.

1942 Commissioned by the War Artists' Advisory Committee to make drawings of coalminers at Wheldale Colliery, near Castleford.

1943 His first one-man exhibition abroad opens at the Buchholz Gallery, New York.

1946 Birth of the Moores' only child, Mary. Georges Braque visits Perry Green. Moore makes his first trip to New York for retrospective exhibition that opens at the Museum of Modern Art.

1947 Travelling exhibition to the state galleries of Australia begins at the Art Gallery of New South Wales, Sydney. Moore carves *Three Standing Figures* for Battersea Park, London.

1948 Appointed member of the Royal Fine Arts Commission (until 1971). Goes to Venice for his one-man exhibition in the British Pavilion at the XXIV Biennale, where he is awarded the International Prize for Sculpture.

1951 Moore's first retrospective at the Tate Gallery; *Reclining Figure: Festival* is exhibited on the South Bank during the Festival of Britain.

1952 A period of intense sculptural
20 activity includes a series of standing

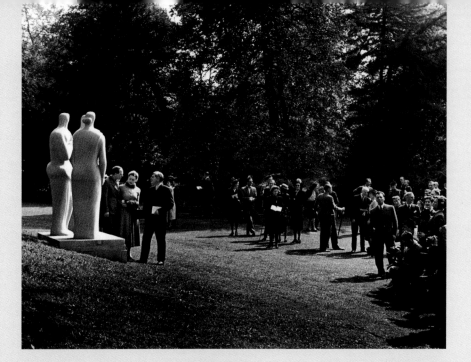

The unveiling of *Three Standing Figures* (1947–48), Battersea Park, London, June 1950. Moore's sculpture was presented to the London County Council by the Contemporary Arts Society. It grew out of what Moore called 'the group sense of communion in apprehension' that he was concerned to reproduce in his drawings of Londoners sheltering from the Blitz. The heads of the three carved female figures are all looking up, as if scanning the sky for enemy planes.

Moore in Venice for the 1948 Venice Biennale, holding *Stringed Figure* (1937).

figures, internal/external forms and reliefs; work begins on two sculptures for the Time-Life Building in New Bond Street, London, and *King and Queen*, all three completed the following year.

1954 Commissioned to design a relief in brick for the new Bouwcentrum, Rotterdam; begins work on *Harlow Family Group*.

1956 Receives a commission for a sculpture for the UNESCO headquarters in Paris.

1963 Moore is awarded the Order of Merit.

1965 Completes *Reclining Figure* for the Lincoln Center for the Performing Arts, New York. Buys a house at Forte dei Marmi, near the Carrara marble quarries in Italy, where he and his family spend summer holidays.

1967 Visits Canada and the US; attends the unveiling of *Nuclear Energy* at the University of Chicago. Is created Honorary Doctor of the Royal College of Art and Fellow of the British Academy.

1968 A retrospective at the Tate Gallery marks Moore's seventieth birthday.

1969 Begins the monumental bronze version of *Large Torso: Arch* and several reclining figures. The gift of an elephant skull inspires a prolonged series of etchings.

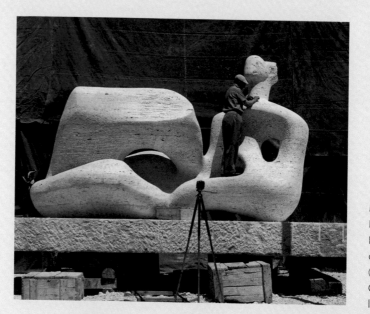

Moore putting the finishing touches to *UNESCO Reclining Figure* (1957–58), in travertine marble, in the forecourt of the new UNESCO headquarters, Paris, designed by Marcel Breuer. The sculpture was unveiled in October 1958.

Moore at the Hermann Noack Foundry in West Berlin, celebrating the casting of *Reclining Figure* (1963–65) for the Lincoln Center, New York, his largest bronze to date.

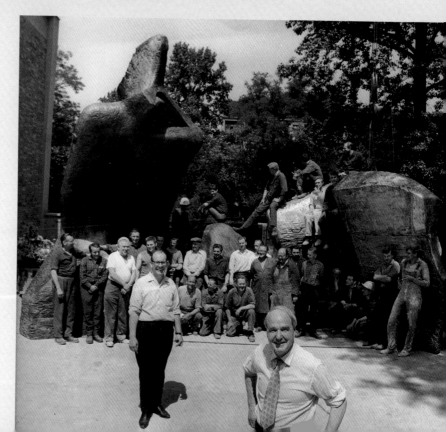

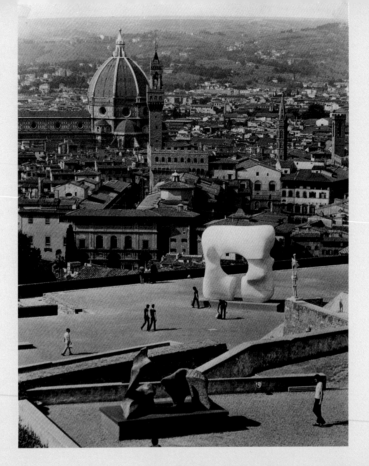

1972 Open-air retrospective is held at the Forte di Belvedere, Florence; Moore attends the opening by HRH The Princess Margaret, and later presents a cast of *Warrior with Shield* to the city of Florence. Begins the *Sheep Sketchbook*, which in turn leads to an album of sheep etchings.

1974 Travels to Canada for the inauguration of the Henry Moore Sculpture Centre at the Art Gallery of Ontario, Toronto, to which he donates 101 sculptures, 57 drawings and an almost complete collection of lithographs and etchings.

1977 Establishment of The Henry Moore Foundation.

1978 Moore's eightieth birthday is marked by exhibitions in London at the Tate Gallery (drawings) and Serpentine Gallery (sculptures); and at the City Art Gallery, Bradford. He donates 35 sculptures to the Tate. *Mirror Knife Edge* is installed outside the new east wing of the National Gallery of Art, Washington, DC.

1980 Tapestries made from his drawings are exhibited at the Victoria and Albert Museum, London. A large marble version

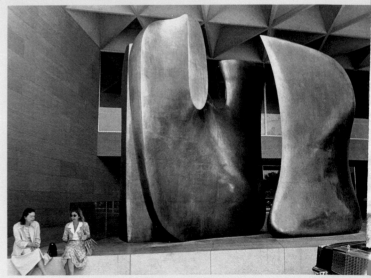

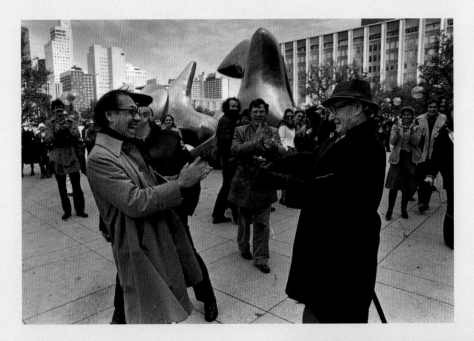

Moore with architect I.M. Pei at the inauguration of *Three Forms Vertebrae* (1968) outside the new City Hall, Dallas, designed by Pei. This unique cast is an enlarged and slightly altered version of *Three Piece Sculpture: Vertebrae* (1968).

Moore at Perry Green with the elmwood *Reclining Figure* (1945–46), preparing for his Arts Council retrospective at the Tate Gallery, selected by David Sylvester, in 1968. The exhibition included 142 sculptures and 90 drawings.

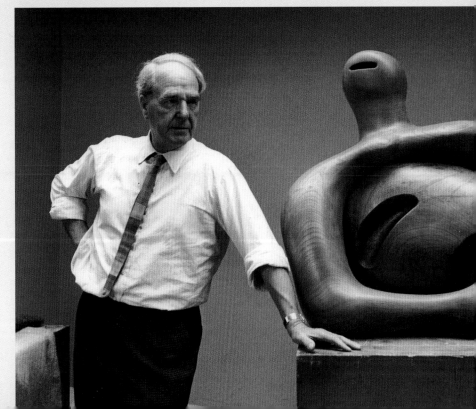

of *The Arch* is donated to the Department of the Environment for permanent position in Kensington Gardens, London.

1982 The Henry Moore Sculpture Gallery and Centre for the Study of Sculpture is opened by HM The Queen as an extension to Leeds City Art Gallery.

1984 Created Commandeur de l'Ordre National de la Légion d'Honneur when President Mitterrand visits him at Perry Green.

31 August 1986 Moore dies at Perry Green, Hertfordshire, aged 88; he is buried in St Thomas's churchyard, Perry Green. A Service of Thanksgiving for his life and work is held on 18 November in Westminster Abbey.

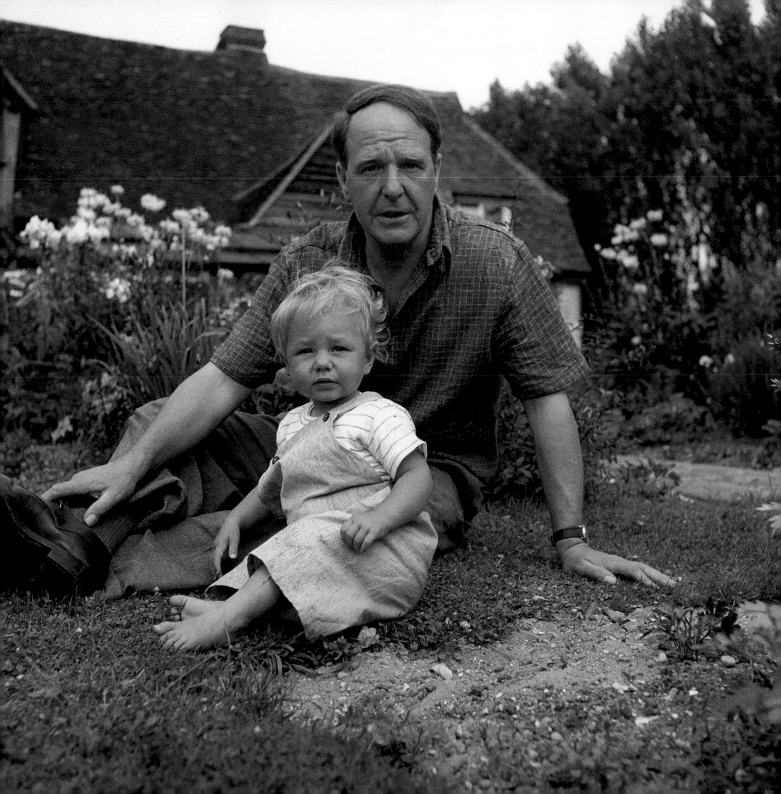

HENRY MOORE AT HOME

Moore with his daughter Mary in the back garden at Hoglands, c.1948.

Hoglands, a modest timber-framed farmhouse, became the home of Henry Moore in the autumn of 1940, during the first weeks of the Blitz. Moore and his wife Irina had been spending a September weekend with the Labour MP Leonard Matters at his country home in South End, Perry Green. On arriving back in London, they discovered that their Hampstead studio had been damaged by a nearby bomb blast, rendering it temporarily uninhabitable. Returning once again to Perry Green, the Moores were persuaded by Matters to rent one half of Hoglands as a stop gap.

The building history of Hoglands is complex, and many alterations have been made over a long period. It probably originated as a single-storey farmhouse in about 1500. The Moores first rented part of the house, later buying the entire building with the help of a £300 cheque for the sale of *Reclining Figure* (1939) to the surrealist Gordon Onslow-Ford.

Moore had delighted in working out of doors since his student days, when his family had moved from their native Yorkshire to Norfolk in an attempt to boost his ailing father's health. The acquisition of Hoglands provided Moore with a quiet location where the artist could immerse himself in his work, but at a convenient distance for reaching the friends, galleries and prospective clients of London.

For many years, Hoglands was more than adequate for the Moores' needs. Following the welcome addition of their only daughter Mary, in 1946, the Moores made minor alterations to the interior, but photographs from the 1940s record a modest, comfortable and convivial family home, with few signs of luxury beyond the curtains and other soft furnishings made by Irina from Moore's own textile designs.

By 1960, however, the ever-increasing flow of clients and

25

left Irina Moore with Mary holding Squeaker, her guinea pig, in the garden at Hoglands, c.1955.

right Irina's garden as it is today. Moore once remarked that for Irina her plants were as important as his sculpture was for him.

overleaf The large sitting room. Flooded with natural light, the room was the setting for the Moores' collection of 19th-century paintings, drawings, ethnographic art, found objects, books and some of Moore's smaller sculptures.

Hoglands, and houses much of Henry and Irina's collection. Every surface is covered with works of art, artefacts from non-western cultures, ephemera and found objects that reveal the Moores' extensive and diverse interests. A full-height bookcase holds a fine collection of art books as well as a selection of drawings and some ethnographic pieces. A piano and a rectangular dining table and four chairs are among the other furniture in the room. The table was never used, providing instead a pedestal-like surface for the display of ethnographic pieces interspersed with *objets trouvés* and Moore's sculptures.

At the far end of the room, double doors lead into the garden. The farmland outside was transformed by Irina Moore at the time the extension was built. This landscape, spreading outwards from the house in a developing panorama, allowed Moore to carefully position works in order to emphasise their sculptural qualities and relationship with nature. Irina's skill and creativity as a gardener were vital to this process. Colour was kept to a minimum and subtle changes to the view were brought about by clever planting, emphasising tone through light and shade. In addition to the self-sown English favourites such as aquilegia, poppies, foxgloves and cowslips, Irina planted many varieties of herbaceous plants in two large beds adjacent to the house. She also liked lavender, and planted whole beds of it at the beginning of the path that wound its way to the studios. A hidden rose garden surrounded a fish pond, and large shrub beds punctuated the lawns. More fruit trees added to the few already planted before 1940 provided a selection of pears, quinces and plums, as well as different varieties of apple.

visitors wishing to see the famous sculptor meant that space was at a premium. A grander drawing room with large windows, allowing uninterrupted views across the garden and beyond, was built as an extension. This became a reception area for the clients, dealers, friends and admirers whose names filled a hectic appointments diary.

Arriving in Perry Green, Moore's visitors entered Hoglands through the porch. They then found themselves in a room with a patterned turquoise-coloured carpet and faced by a wall-mounted cabinet filled with an eclectic assortment of pre-Columbian, Oceanic and Cycladic figures that Moore had collected over the years.

Just to the right of the lobby is the entrance to the large sitting room, which still remains the focal point of any visit to

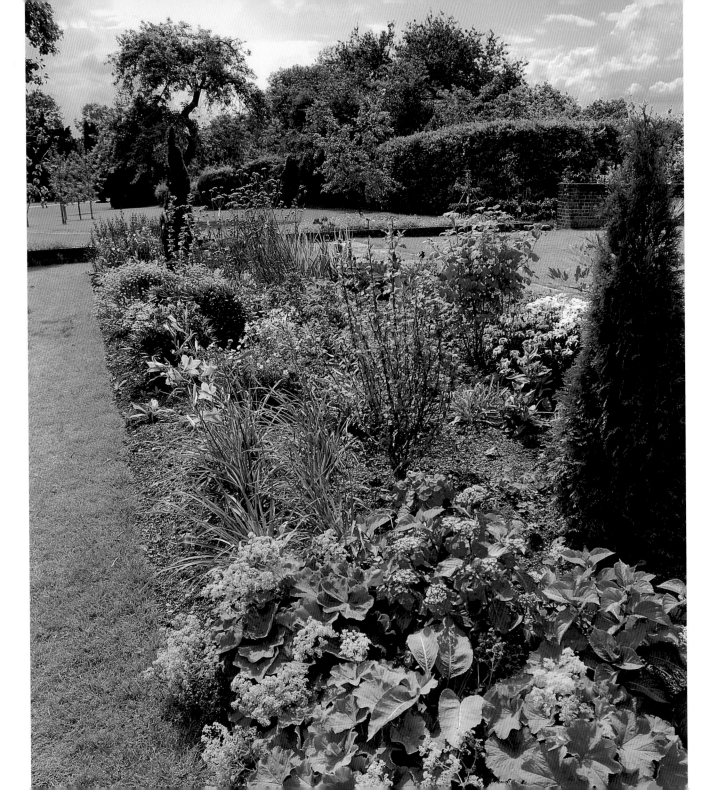

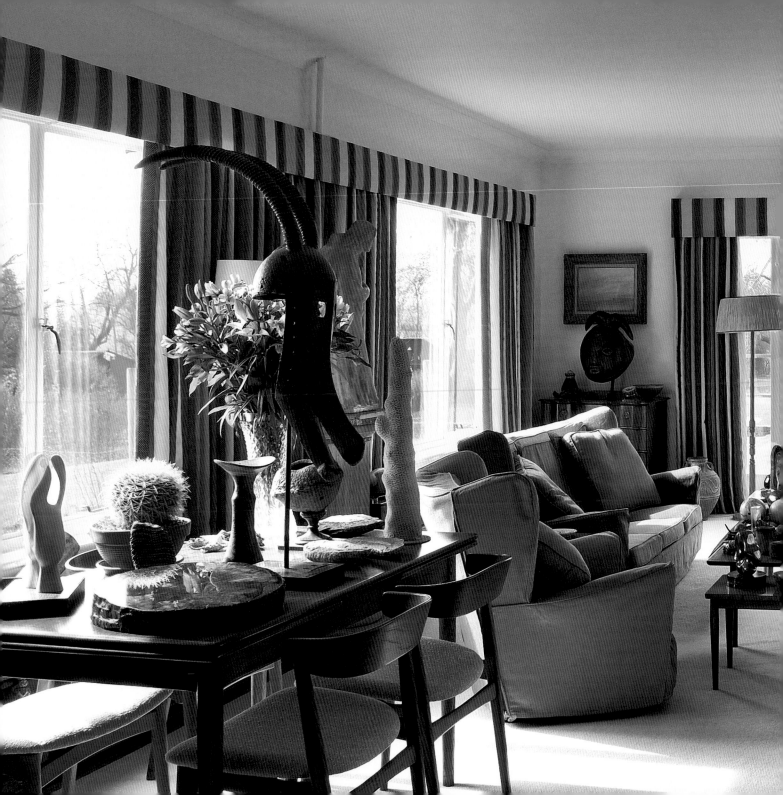

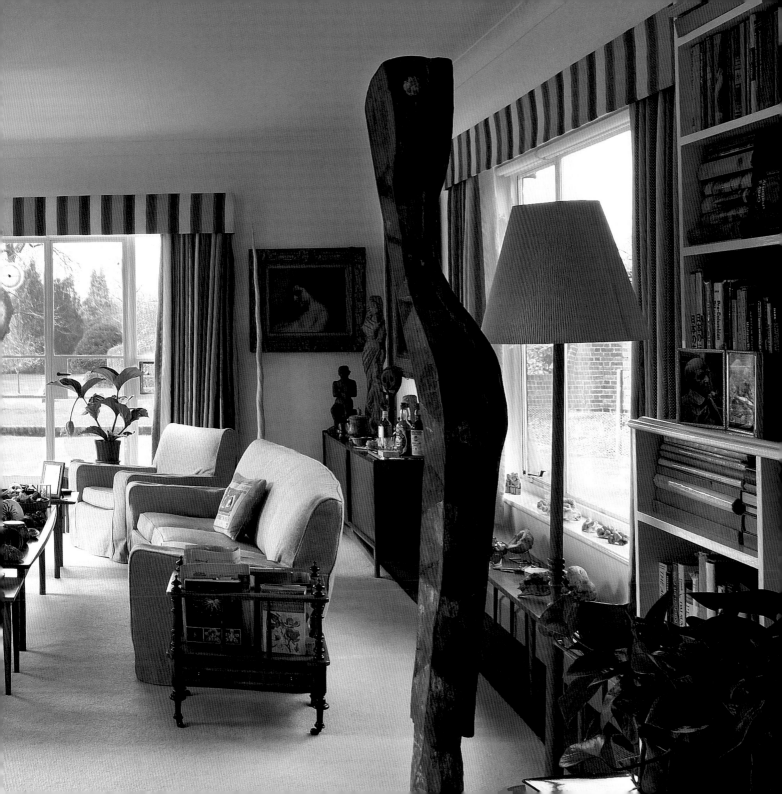

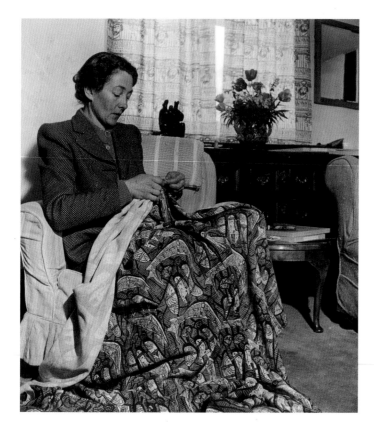
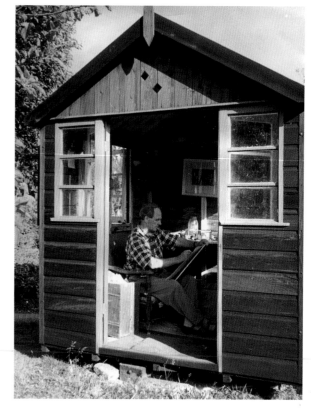

In the older part of the house, it is possible to see the Moores' private sitting room, where, despite the constant flow of visitors, Irina found time to sew and complete her jigsaw puzzles. Opposite, a small kitchen gave her ready access to her beloved garden. Steps lead down into the office, where Moore and his staff took care of business affairs, and where the artist also kept a large collection of photographic equipment and prints – all geared to the production and sale of his work. Beyond lie the more domestic areas: a formal dining room, traditionally arranged with a dresser and candlelit table; a simple kitchen; and finally a brightly lit sun room for afternoon tea. This last room was much loved by the Moores, who took as many meals there as possible. Surrounded by a selection of ever-changing plants from the large greenhouse are an attractive seventeenth-century oak table and six chairs placed on a vivid purple carpet.

Other than for holidays and frequent business trips abroad, Henry and Irina Moore spent more than half of their lives at Hoglands, the artist preferring not to leave his work for long. After their deaths, in 1986 and 1989 respectively, the house remained in the ownership of their daughter Mary and her children until, in 2004, it was acquired by The Henry Moore Foundation. The artist's family had kept the interiors exactly as they had been while Moore was alive, with contents still *in situ* and works of art in safe storage. Following renovations by the Foundation, all items were faithfully returned to their original positions in each of the ground-floor rooms, which opened to the public in 2007. This recent purchase and restoration of Hoglands has put it once again at the centre of events in Perry Green.

far left Irina Moore in the small sitting room at Hoglands making curtains from *Horse's Head and Boomerang* (1944–45), one of the textiles Moore designed for Zika Ascher. Curtains made from *Heads*, another of the artist's designs, hang in the window behind her.

left Moore drawing in his revolving summer house, 1956.

right The dining room, 2007.

below right The small sitting room after the house opened to the public in 2007.

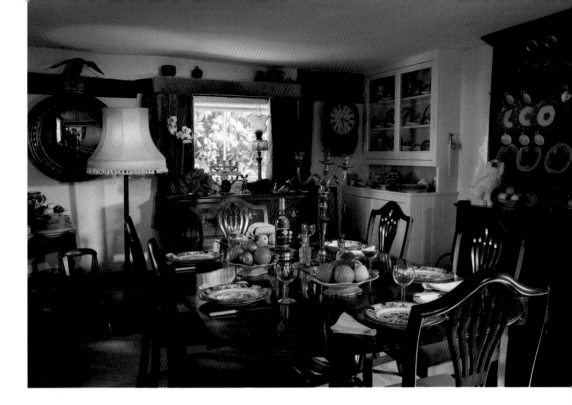

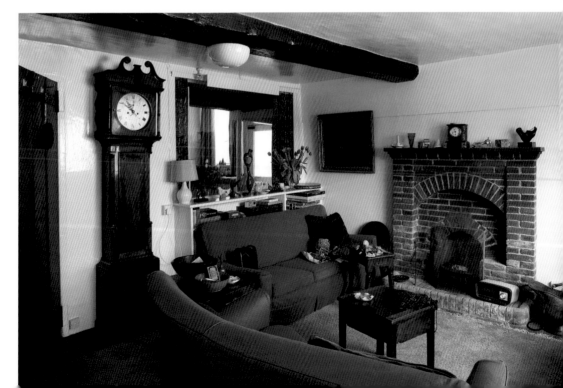

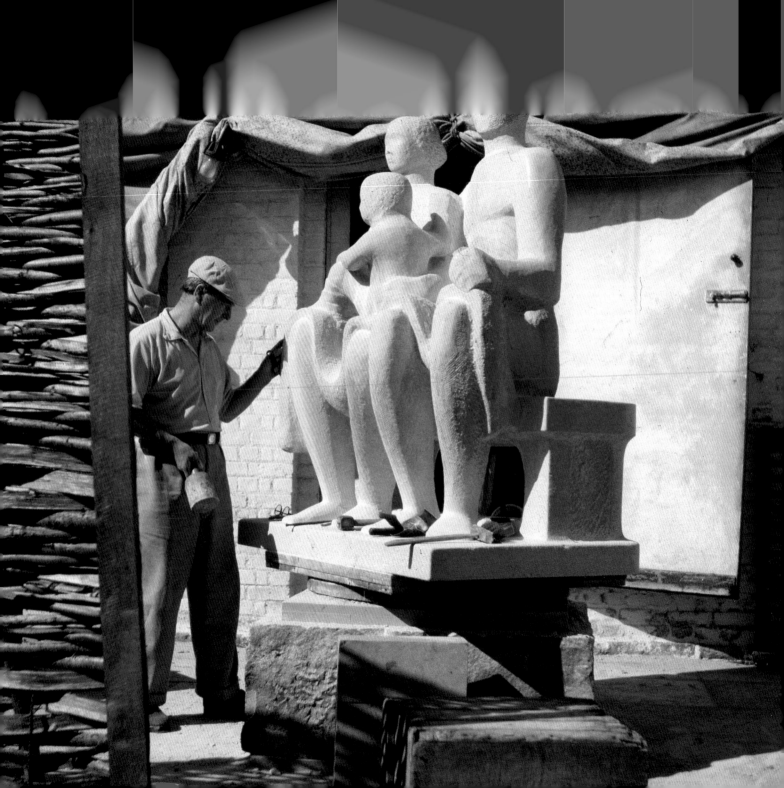

HENRY MOORE AT WORK

When the Moores moved to Perry Green in 1940, the opportunity to move into a relatively large house possessing not only sizeable gardens but most usefully a stable building that could serve as a workshop must have been irresistible; Moore immediately set to work laying the floor of what was to become his most important studio by far. None of Moore's studios were grand, and this space, now called the Top Studio, is typical of the converted old sheds and stables that he favoured: unprepossessing though easily adaptable, draughty and often cold, but serviceable and with good light.

Moore's approach to sculpture was always immediate and direct. At the beginning of his career he worked principally on carvings in both wood and stone. Moore was just sixteen when he produced his first carved work: a war memorial Roll of Honour for his school in Castleford, Leeds. This technique would later become a significant mode of production throughout his artistic career, particularly between 1920 and 1940, when nine out of every ten sculptures he made were carvings.

As a young sculptor, Moore had an almost fanatical belief in carving. He liked the physical action and mental attitude involved in working directly with the material, and always maintained a carver's approach to sculpture rather than a modeller's, even when working in clay or plaster for casting in bronze.

To me carving direct became a religion ... I like the fact that I begin with the block and have to find the sculpture that's inside it. You have to overcome the resistance of the material by sheer determination and hard work.

Moore carving *Harlow Family Group* (1954–55) outside the Top Studio. The family group became an important theme in Moore's work after the Second World War, reflecting his more humanist approach to making sculpture for public sites. *Harlow Family Group* was based on a maquette of 1944.

THE TOP STUDIO

Situated adjacent to Hoglands, the Top Studio is the space in which Moore made some of his most important mid-career carvings, including *Three Standing Figures* (1947–48). *Reclining Figure: Festival* (1951) was also made here but, with the acquisition of further land in 1955, sculpture production gradually moved to newer, purpose-built studios.

Early in his career, Moore drew preliminary sketches on paper for his sculptures, but after 1935, when the size of his pieces increased, he would make small studies in three dimensions, known as 'maquettes' (after the French word for 'small model'). These maquettes were initially created in the Top Studio, stored in ranks along shelving that lined the walls.

THE ETCHING STUDIO

An adjacent building housing the village general store became vacant a few years after the Top Studio was set up. With its private atmosphere and north-facing skylights, this became an ideal space for developing sculptural ideas, and soon became Moore's preferred room for the creation of maquettes. Moore's ideas came from a number of natural sources, and the studio was soon filled with found objects such as bones, flints, roots, pebbles, shells and other natural detritus. Through these objects, Moore studied 'Nature's way' of working materials: the 'jagged nervous block rhythm' of rocks, or the 'hard but hollow form' of shells with a 'wonderful completeness of single shape'.

It remained Moore's principal creative space until 1970, when it was superseded by the purpose-built Bourne Maquette Studio. The former shop then began yet another incarnation, as the centre of Moore's experiments in etching, which is how it is seen today.

left The Etching Studio today.

right Hoglands and the Top Studio.

below right *Time-Life Screen* (1952–53) in front of the Top Studio. Moore would often create his larger carvings outside the low-ceilinged building. This four-part relief sculpture, in Portland stone, screens the roof terrace of the Time-Life Building in New Bond Street, London.

THE BOURNE MAQUETTE STUDIO

The original contents of the Etching Studio – Moore's maquettes and found objects – were moved to a purpose-built studio further down the estate. This new space, the Bourne Maquette Studio, consists of two similar-sized rooms overlooking the sheep field and the more rural areas of the estate beyond. This studio was at the heart of the creative process, a place where Moore could go to think, to work, and to get away from the activities and distractions elsewhere on the estate. It remains as it was during his lifetime, though a few changes have been made in order to accommodate additional visitors, security and conservation concerns. The largest alteration was the addition of a window to the inner room to facilitate public viewing.

The monumental bronze sculptures by Moore all began as plaster maquettes, small enough to be held in the palm of the artist's hand. Some early works have not survived due to the fragility of the plaster, but the room remains filled with maquettes – finished, uncompleted, fragmented – as well as tools, Moore's collection of found objects, plus his walking stick and chair.

In one corner of the outer room sit two of Moore's favourite natural objects: a rhinoceros skull and an elephant skull that were given to him by Juliette Huxley in 1968. The elephant skull in particular, with its sense of mystery and complexity of detail, became an important source of inspiration. At once both strong and fragile, the hard external curved forms surround delicate structures within a dark cavernous space. The skull inspired several sculptures, as well as works on paper.

When Moore wished to make the subject of a particular maquette on a much larger scale, an intermediary 'working model' was made. From about 1950, Moore favoured plaster for

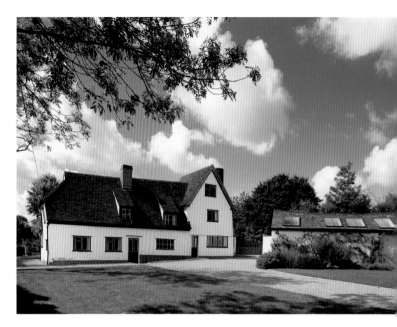

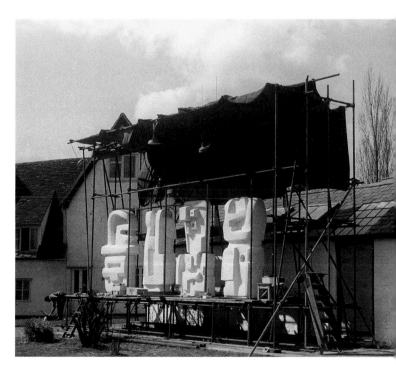

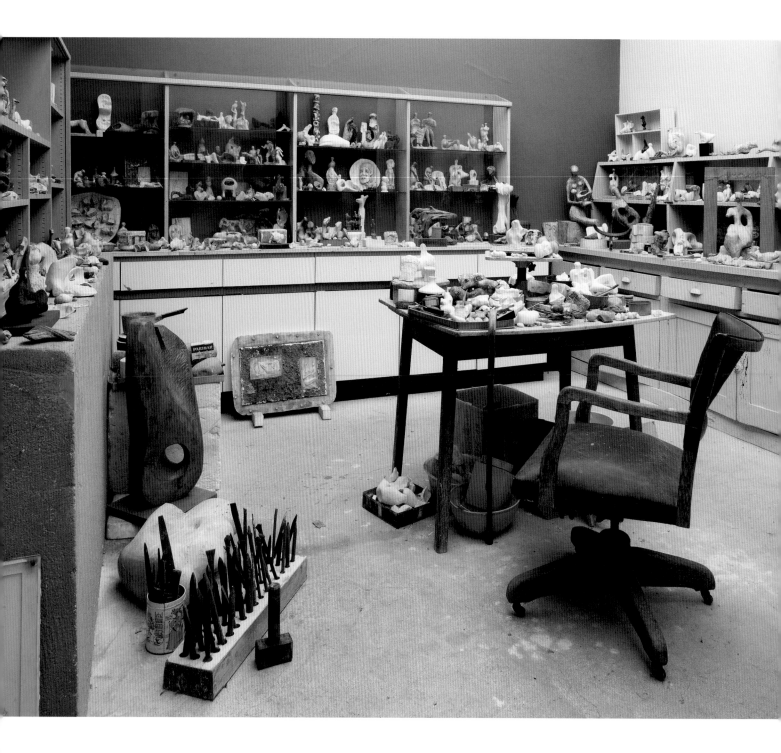

left The Bourne Maquette Studio in 2010. The studio was where Moore could be alone, finding inspiration in the numerous natural objects which he had collected, and modelling his small plaster maquettes.

right The reconstruction of Moore's Plastic Studio. In such a shelter the artist could work on very large sculptures in all-round light in all seasons. Moore believed that 'a big sculpture intended to live out-of-doors permanently is better if actually made out-of-doors'.

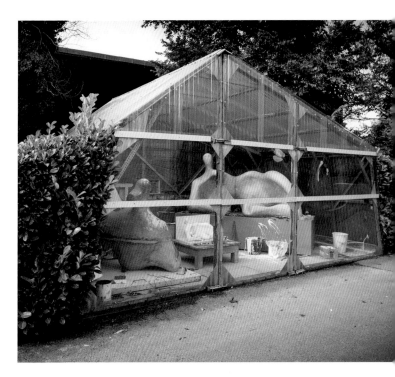

many of the working models: it was malleable when wet and could be carved when dry.

Although the plasters were often transitional, as with the maquettes they are sculptures in their own right and for many subjects are the final versions. The plasters were worked with various tools such as files and cheese-graters to provide a textured surface, and sometimes coloured with walnut crystals to create a warm bone-like tint, recalling many of the found objects. The green deposits on the plasters result from shellac coatings used during the casting process, or from bronze dust settling on them while at the foundry. Moore admired this effect and sometimes imitated it with a watercolour wash.

THE WHITE STUDIO

In 1950, the White Studio was built specifically for the purpose of enlargement, providing the perfect space in which Moore could scale up his working models to monumental proportions. This initially involved working with a wooden or metal armature, wire netting, hessian and plaster. As this could be very time consuming, the plasters were often made by one of Moore's assistants. Moore then completed the process, making any alterations to the proportions and form, before working on the surface texture. Moore's assistants played an important role in the production of his sculpture and continued to do so until Moore's death. Over 50 different sculptors worked for him over a period of 50 years. In addition to assisting with carving and helping to enlarge works, they sometimes applied patinas to the bronzes. The White Studio is used today by the Foundation's sculpture conservators and is not open to the public.

THE PLASTIC STUDIO

In the early 1960s, Moore transferred the enlargement process to the Plastic Studio, located opposite the White Studio. The Plastic Studio was created when Moore was working on the Lincoln Center *Reclining Figure* (1963–65), the largest work that he had made to date. Knowing that it could not be completed during the summer months, the construction of a transparent studio allowed the artist and his assistants to work on it in natural light in all weather.

It was at this point that Moore also started to experiment with new materials, discovering that he could slice up his working models and use a grid system to scale up the sculpture. Using blocks of polystyrene, which could be cast from directly or covered in a layer of plaster to add strength and achieve the desired surface, he was able to produce work on a monumental scale; polystyrene was also much lighter and easier to manoeuvre than plaster.

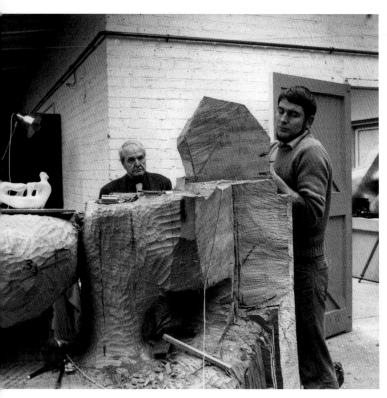

left Moore with assistants in front of the Yellow Brick Studio about to turn over *Reclining Figure: Holes* (1976–78) so that it could be worked on underneath.

below left Moore with assistant Michel Muller working on *Reclining Figure: Holes*.

right The Yellow Brick Studio today. In Moore's day it served primarily as a place for carving in wood and stone.

These enlargements were then cast in bronze. Throughout his career, Moore employed a number of professional foundries to cast his work both in England and abroad. Before the works returned to Perry Green, any welding marks or blemishes were removed. Moore would then carry out further work on them to remove imperfections, bringing out their metallic quality to achieve the desired finish. Bronze turns green naturally, and while Moore would sometimes leave a sculpture to reach this state over time, he usually applied chemicals to speed up the process, conceal welding joints and to create a variety of colours. A beeswax or lacquer coating could then be applied to prevent oxidisation and further changes to the surface.

A smaller version of the Plastic Studio has since been recreated by the Foundation, in which the original polystyrene and the plaster for *Draped Reclining Mother and Baby* (1983) can be seen.

THE YELLOW BRICK STUDIO
The Yellow Brick Studio was built in 1958 on the site of an old pigsty acquired by Moore when he purchased neighbouring farmland. This was the second purpose-built studio added to the estate and, along with the White Studio and future Bourne Maquette Studio, it soon became a hub of activity central to production at Perry Green.

Plans for the studio show that it was intended to provide Moore with a new 'Sculpture Store & Showroom'. This was a necessary and welcome addition to his facilities, as it would deal with an overflow of work from the White Studio and provide a separate space free of plaster dust for the return of bronzes from

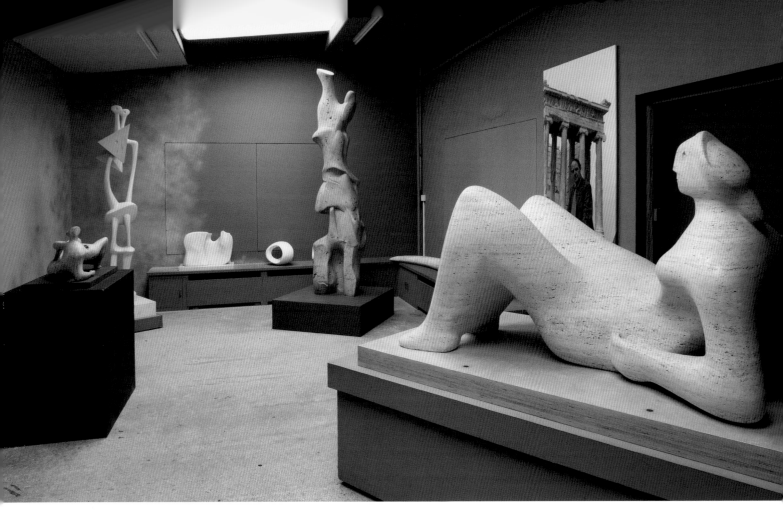

casting. It also provided a viewing area for potential buyers.

Primarily, however, Moore looked upon the Yellow Brick Studio as a space for carving. Previously he had used the Top Studio, but he eventually found it too small and low for making larger works. The new studio was more suitable, and it was here that he worked on some of his most important carvings, particularly a series of large-scale figures in elmwood created between 1959 and 1977.

Elmwood was not the only material Moore worked with here. Between 1964 and 1973, his interest in stone carving was renewed through visiting quarries and stoneyards during summers spent at his holiday home in Forte dei Marmi, Italy.

From 1964, Moore sent plaster maquettes and working models to artisans at the Henraux stoneyards in Italy, which they would enlarge and then carve under his supervision. Although begun at the stoneyards, Moore completed them in the Yellow Brick Studio during the winter months.

On Moore's death in 1986, all production ceased. The studios, whilst remaining structurally unchanged, became display areas, tracing Moore's artistic process from the conception of a sculpture to its realisation on a grand scale. Today, these small buildings scattered throughout the grounds allow a glimpse into Moore's world, illustrating the diversity and breadth of his sculptural practices.

The Top Studio in 1969

This outbuilding, a former stable, was the first space which Moore took over and converted into a studio after moving into Hoglands in 1940. Many of his most important sculptures in the decade after the Second World War were carved or modelled here; or, if too large, such as *Time-Life Screen*, under a canopy immediately outside (see p.35). The large white plaster in the left foreground is *Working Model for Oval with Points* (1968–69).

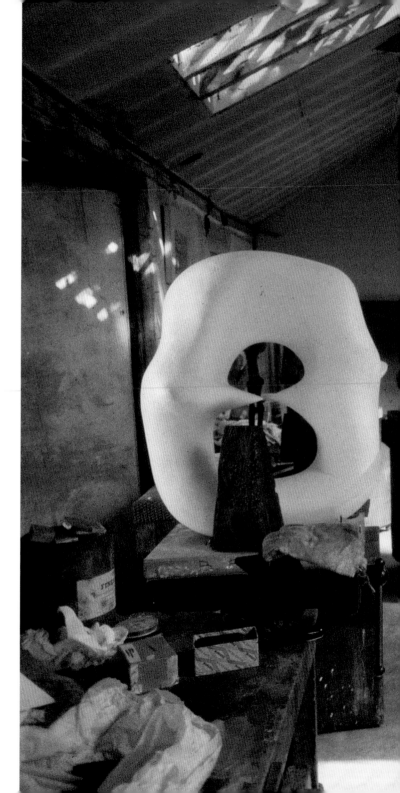

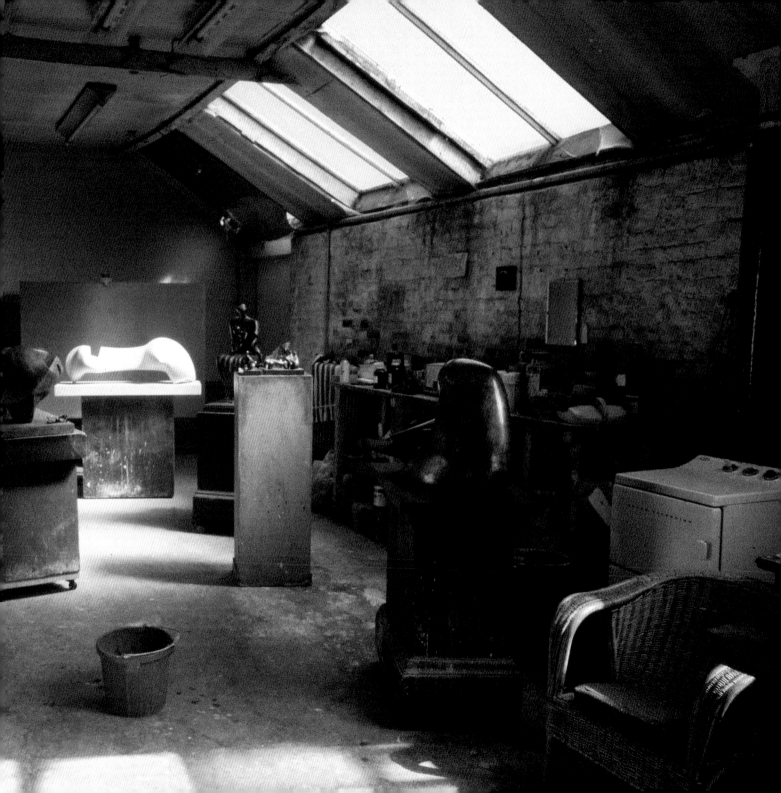

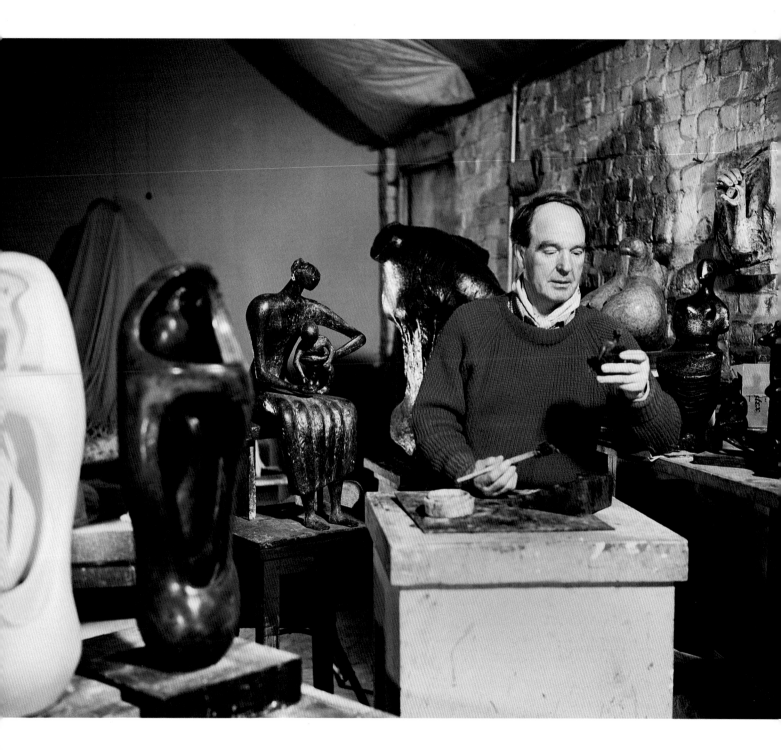

Henry Moore in the Top Studio, *c.*1956

Surrounded by works including *Maquette for Upright Internal/External Form* (1951), *Mother and Child with Apple* (1956) and *Draped Torso* (1953). The artist is either painting or varnishing the plaster *Maquette for Figure on Steps* (1956).

The Top Studio

The Top Studio in the early 1960s, with many works including *Helmet Head No.4: Interior-Exterior* (1963) on left, *Seated Figure Against Curved Wall* (1956–57) centre, and *Working Model for Knife Edge Two Piece* (1962) foreground right.

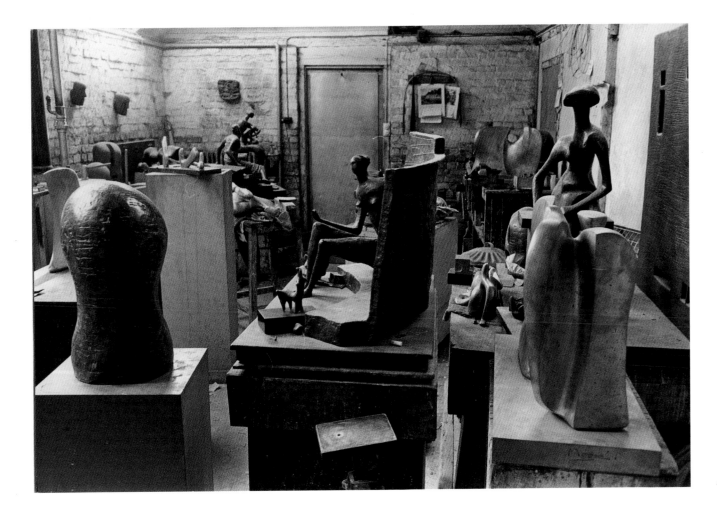

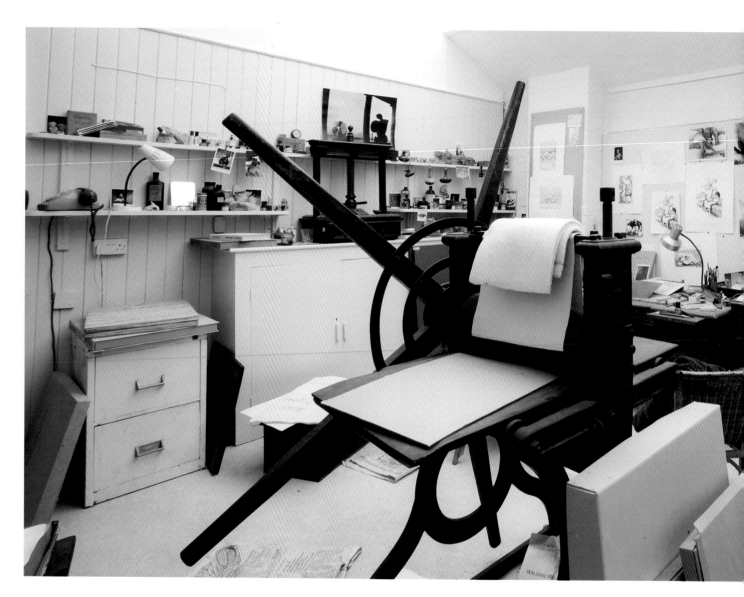

The Etching Studio

Originally the village store, this building first housed Moore's collection of natural found objects, the genesis of many of his small plaster maquettes which he would model by hand here. Moore said he liked 'the disarray, the muddle and the profusion of possible ideas in it...

It is where I am most personally isolated, and that's probably why I like it so much'. In 1970, this activity moved to the Bourne Maquette Studio and the building became Moore's etching studio.

Moore's interest in printmaking began

tentatively after the First World War and intensified from the mid-1960s, continuing to the end of his life. Following his aquisition of an etching press in the 1970s, Moore worked with specialist printers and publishers internationally to meet a growing demand for his work.

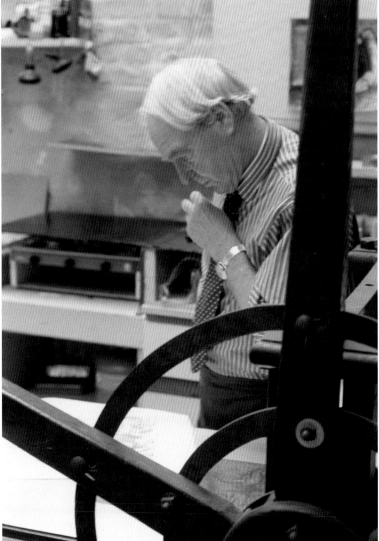

Henry Moore in the Etching Studio

Moore's prints were conceived for a variety of reasons: from appearing
in luxury books alongside the work of selected poets – W.H. Auden and
Lawrence Durrell, for example – to little-known, one-off graphic projects
by the artist; a wine label for the 1964 Mouton Rothschild vintage; Moore's
personal book plate, and a print produced as part of an innovative scheme
to introduce modern art to schools after the Second World War.

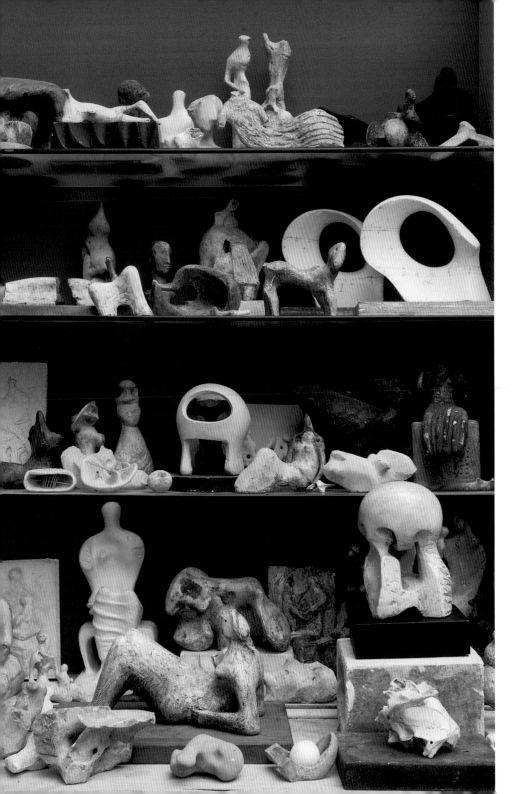

Shelves in the Bourne Maquette Studio, 2009

The studio remains as it was during Moore's lifetime, replete with his tools, found objects and plaster maquettes. Preliminary models for a number of large sculptures are visible in this photograph, including *Double Oval* (1966), on the second shelf from the top, and *Atom Piece* (1964), on the black plinth, bottom right.

Moore at work in the Bourne Maquette Studio, 1982

As a sculptor, Moore was committed to the 'full realisation of form in the round'. Each maquette was made in a size that could be held in the hand or worked on a small turntable, allowing Moore to view it from every angle.

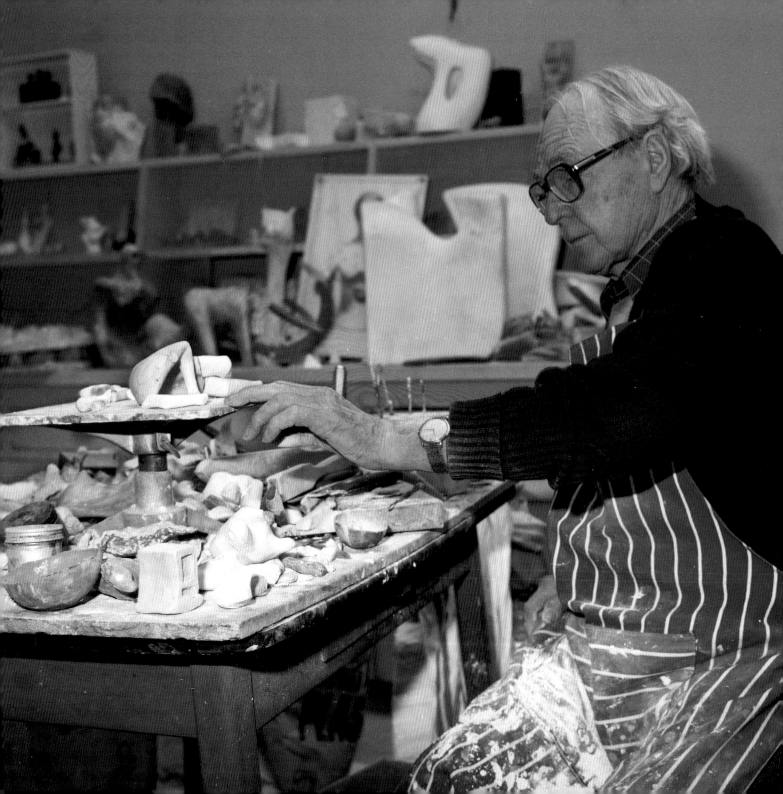

The Plastic Studio

In 1963, Moore built outdoors a large metal frame covered with a transparent plastic material so that he could work on the plaster for his enormous two-piece *Reclining Figure* (1963–65) for the Lincoln Center, New York, over the winter months in natural light. All Moore's subsequent large sculptures were made in the Plastic Studio which gave the artist the all-round light he preferred for creating outdoor pieces. Today, a smaller reconstruction of the original contains the plaster and polystyrene working models for *Draped Reclining Mother and Baby* (1983). Moore started using polystyrene in the 1960s. Much lighter than plaster, it can be moved around and worked with ease, though it is more easily damaged.

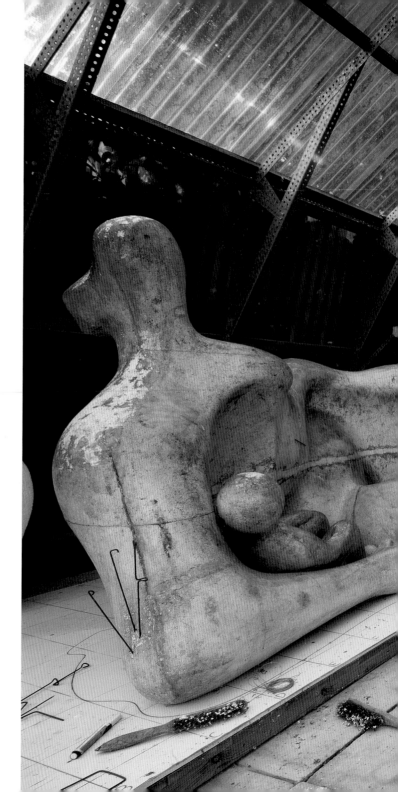

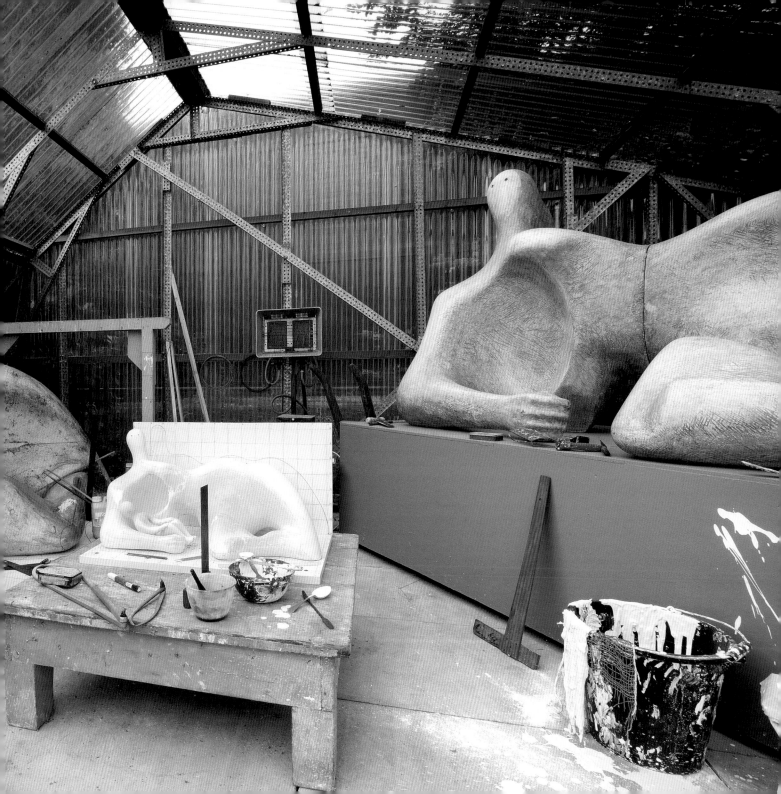

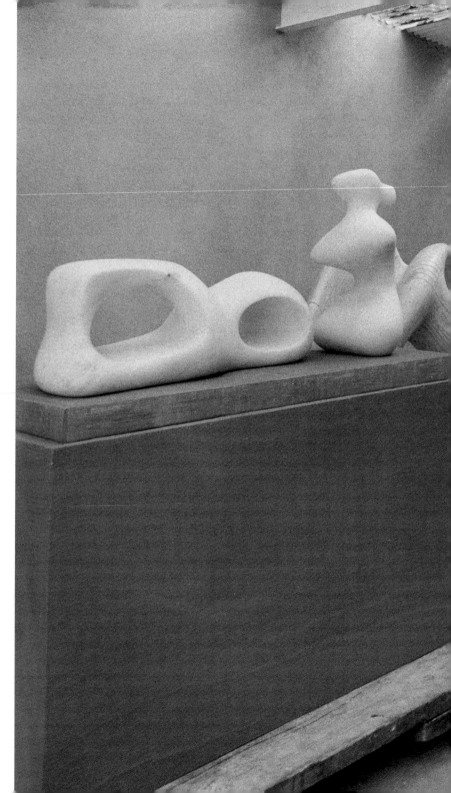

Moore in his sculpture studio

Moore is seen with (among other works) the
original plaster for *Reclining Figure: Festival* (1951),
on the low pedestal, second from the left. The
bronze was commissioned by the Arts Council
for the Festival of Britain and sited temporarily
on the South Bank, London, in 1951. Based on
sketches and maquettes made in 1950, it is the
first of Moore's fully 'opened out' sculptures,
in which form and space, solid and void, are of
equal value in the reading of a figure. Moore
gave the plaster to the Tate Gallery in 1978 and
the bronze cast that was shown at the Festival
of Britain is now in the collection of the Scottish
National Gallery of Modern Art in Edinburgh.

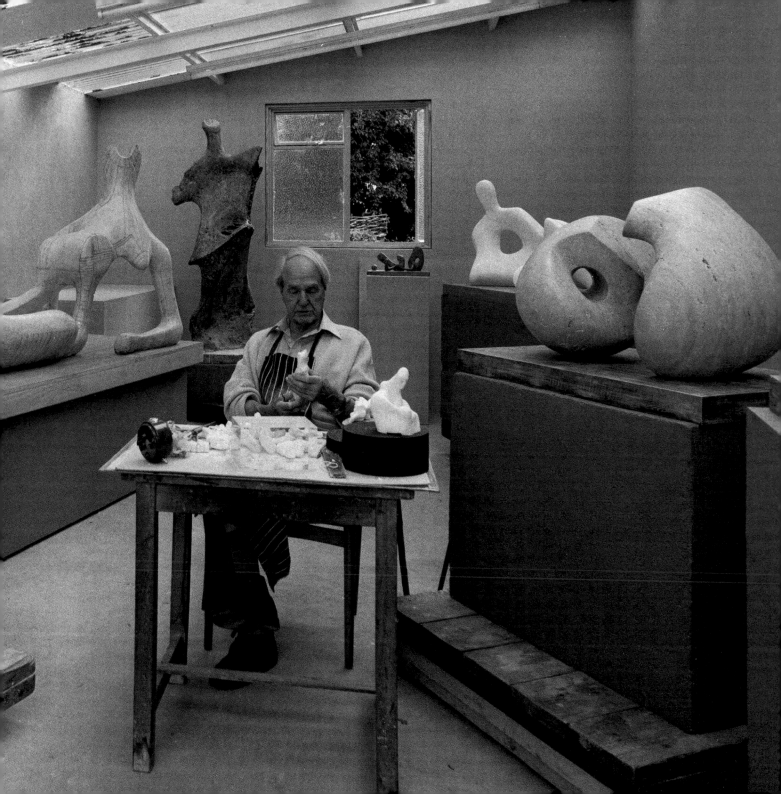

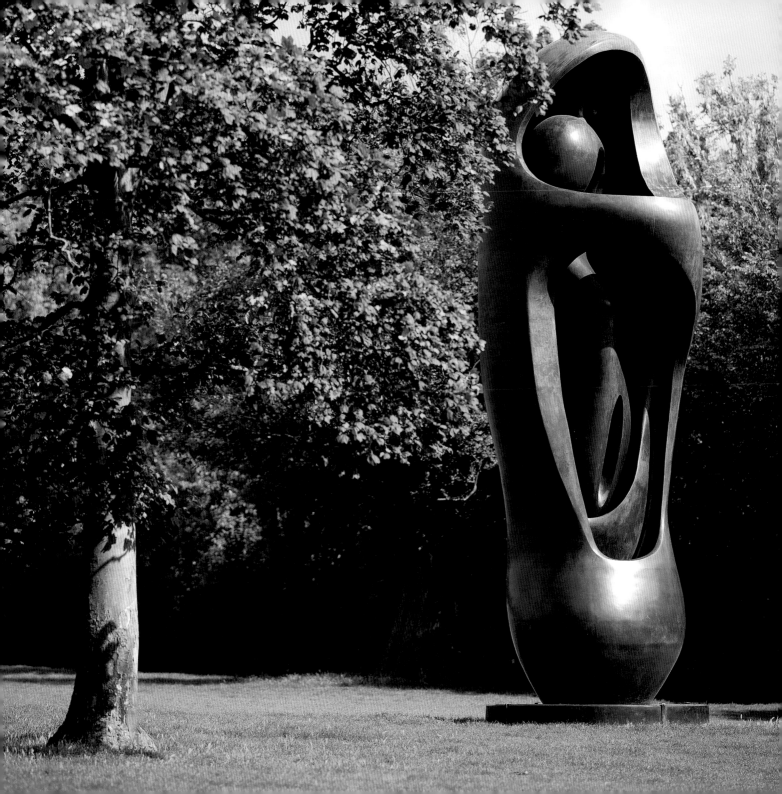

HENRY MOORE SCULPTURES

By concentrating initially on a small number of subjects – the head, the mother and child, the reclining nude, the family group – Henry Moore created unforgettable images of the human condition. He later expanded this vocabulary to include more inventive forms that interlock, touch, point, split into two or more parts, or contain one form within another. However abstract they may appear, all of these forms are ultimately derived from nature.

Moore preferred his sculptures to be seen outdoors in natural surroundings, maintaining that the optimum landscape consisted of sky and fields of grass with a few trees. At Perry Green, he was able to experiment with the siting of his work against a harmonious but constantly changing backdrop that shifted with the seasons. All of his sculptures are free-standing, capable of being seen from 360 degrees. Of the monumental bronzes illustrated here, some are now on permanent display at Perry Green, while others are sited for short periods of time according to the demands of the Foundation's busy exhibition programme. Smaller bronzes from the collection are also placed in the grounds at regular intervals; the maximum on the estate at any one time will be around 30. Each is subject to changing light and weather conditions that ensure no two visits are alike.

Large Upright Internal/External Form 1981–82
This is the largest of Moore's sculptures to reveal an internal form being protected by an outer shape. The vulnerable interior appears to be shielded by the encircling or embracing outer form. This sculptural concept can be linked to Moore's mother and child sculptures; and also to his series of helmet heads begun in 1939, in which the interior of the helmet is often a small figure and the outer casing resembles armour.

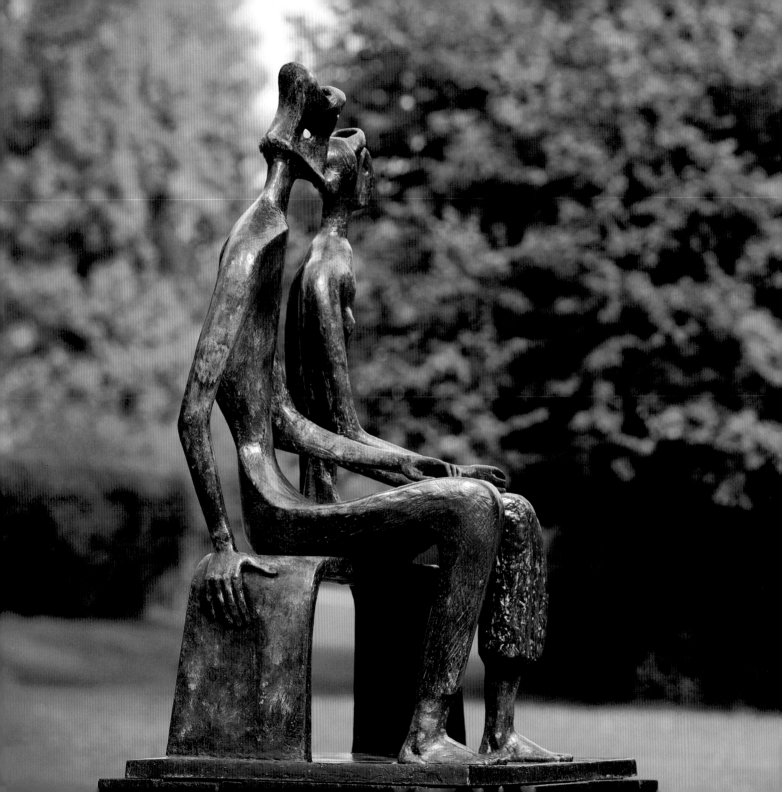

King and Queen 1952–53

This sculpture is the culmination of a number of studies of heads, hands and single figures. Moore arrived at the initial idea after modelling a bit of wax and realising it resembled a bearded Pan-like head with a crown. The title was inspired by his readings of fairy tales to his daughter Mary, then aged six. Art historians have commented on the likeness to Egyptian sculptures in the British Museum, which Moore frequented as a student. He explained: 'The King is more relaxed and assured than the Queen, who is more upright and consciously queenly. When I came to do the hands and feet of the figures they gave me a chance to express my ideas further by making them more realistic – to bring out the contrast between human grace and the concept of power in primitive kingship.' The sculpture's most photographed siting is at Glenkiln in lowland Scotland, a moorland estate belonging to Moore's friend Sir William Keswick, who acquired a total of four sculptures by the artist.

Family Group 1948–49 >

Just prior to the Second World War, Moore was approached by the architect Walter Gropius to make a sculpture for a new school at Impington, near Cambridge. The school's intended role fitted the socialist ideology of the time, since it was meant to become a focus of community life for the surrounding villages as well as a centre of education with the full involvement of the parents. Moore liked the idea and felt that the subject of a family group would be appropriate. He subsequently made a number of maquettes and drawings on the theme. It was not until after the war that the funds were secured to produce the sculpture for Barclay School, in Stevenage. Moore agreed to make the sculpture at cost price (casting, transport and materials). The birth of Moore's daughter Mary in 1946 also contributed to his interest in the theme of the family.

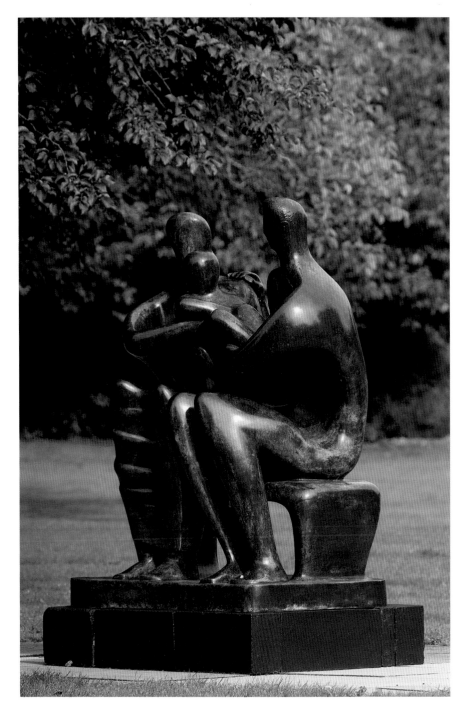

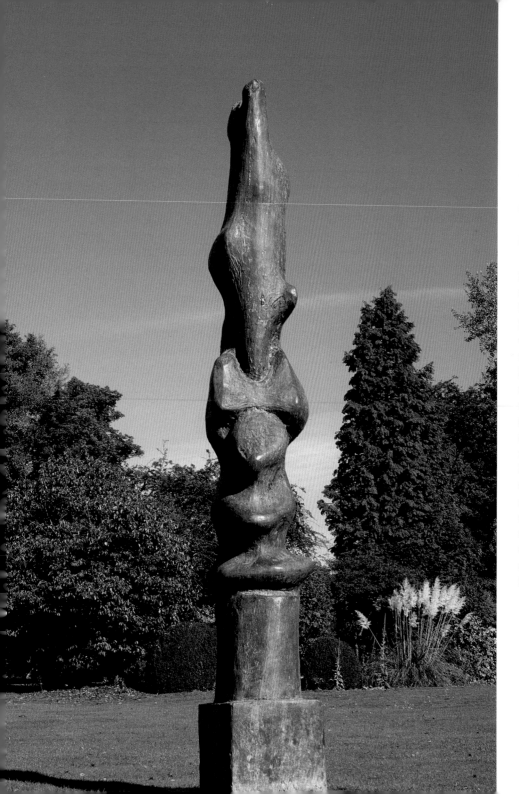

Upright Motive No.7 1955–56

Upright Motive No.5 1955–56 >

Upright Motive No.8 1955–56 >>

In 1954, Moore was commissioned to produce a sculpture for the courtyard of the Olivetti building in Milan. 'A lone Lombardy growing behind the building convinced me that a vertical work would act as the correct counterfoil to the horizontal rhythm of the building... I started by balancing different forms one above the other – with results rather like North American totem poles – but as I continued the attempt gained more unity and also perhaps became more organic.' Although the project was never realised, the maquettes that Moore created became the impetus for the upright motive series. Five of the 13 maquettes which Moore made in 1955 were enlarged. *Upright Motive No.1*, which has a cruciform head, became known as the 'Glenkiln Cross' after the estate in south-west Scotland where a cast of it was sited, on a rocky outcrop not far from *King and Queen* (p.54).

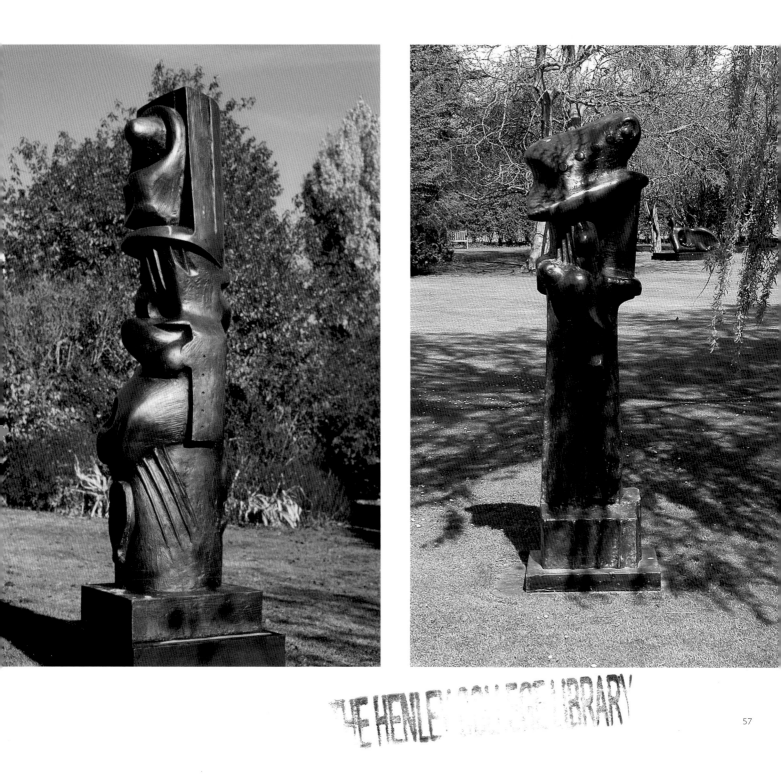

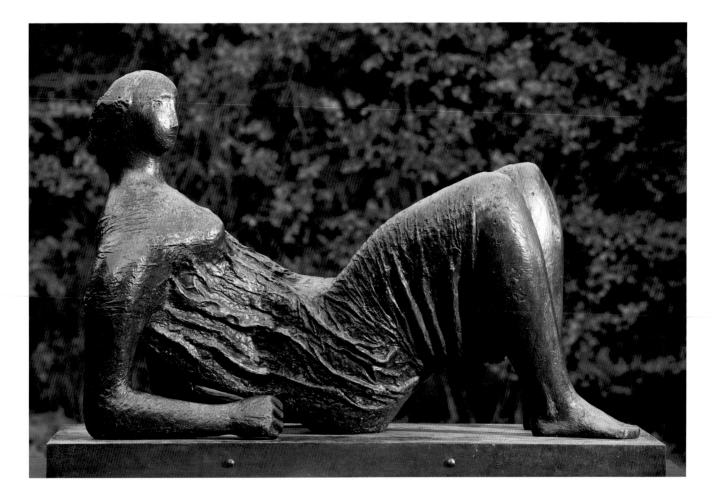

Draped Reclining Figure 1952–53

The boom in building construction after the Second World War reawakened an interest in public sculpture in Britain. Moore made an effort to produce humanist sculpture that instilled a sense of civic pride and was accessible to the public. A cast of this work was sited on the roof terrace of the Time-Life Building in London behind an abstract relief by Moore which forms an integral part of the building visible from New Bond Street. The pose of this figure can be related to those found in Moore's sketches of people sheltering from the Blitz in the London Underground. Blankets cling to the figures, revealing their form. The use of drapery also reflects the ancient Greek sculptures Moore knew from the British Museum and from travels in Greece in 1951 following his exhibition in Athens.

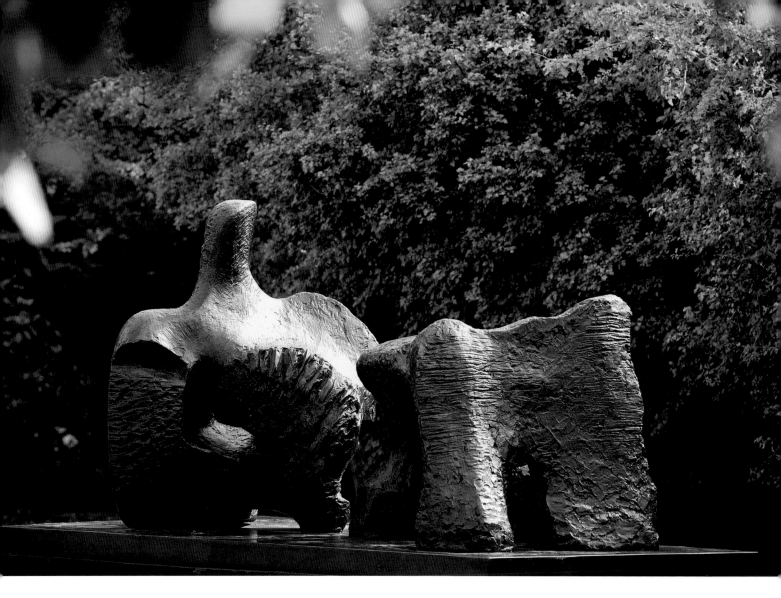

Two Piece Reclining Figure No.2 1960

Moore's interest in dismembered figures, or bodies with missing parts, dates to the 1930s; but in the series of large, two-piece reclining figures of 1959–61, of which this is the second, he recognised that he was using the spaces between the discrete forms more sculpturally than ever before – they were an integral part of the work. He also realised that by splitting the composition in two, the sculpture had a much closer relationship to landscape. 'Knees and breasts are mountains. Once these two parts become separated you don't expect it to be a naturalistic figure; therefore, you can justifiably make it like a landscape or a rock.'

The Wall: Background for Sculpture 1962

This sculpture is the result of an experiment made when Moore was facing the challenge of placing a sculpture within an architectural setting. The wall was intended as a background for a sculpture, which would form a visual barrier between the sculpture and the architecture. It is closely related to a number of smaller sculptures Moore made in the late 1950s of figures seated in front of walls. The walls in each case are made more visually interesting by breaking up the flat plane with holes and strong textured areas; in some examples the walls are tilted and curved dramatically. While this idea worked on a small scale, the sculptures when enlarged were more successful without a walled background, so Moore abandoned the idea.

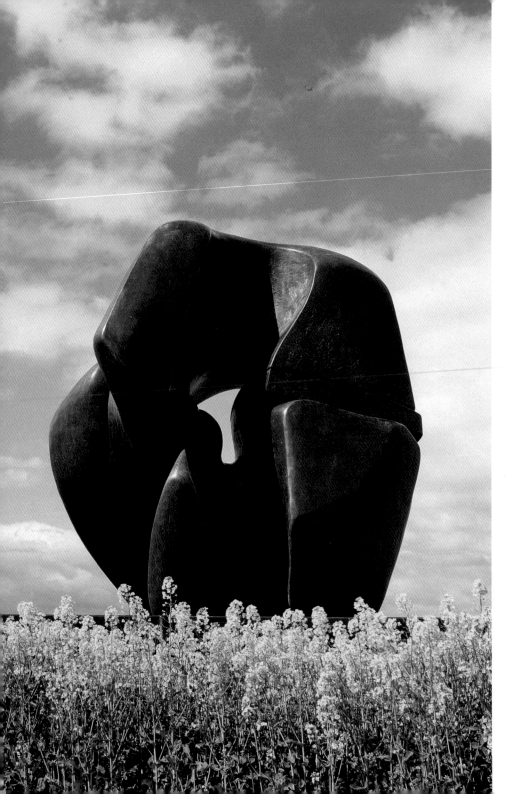

Locking Piece 1963–64

This is the first of a group of large, compact sculptures in which Moore discovered a new freedom of scale once he had moved away from enlarging the human figure beyond life-size. He said that a sawn fragment of bone with a socket and joint had given him the 'germ of the idea' for this sculpture. Part of this bone, which appears to be half a vertebrae, is still in his studio at Perry Green, marked up for enlargement. Interlocking forms also reminded him of children's puzzles, where parts fitted together in a particular way, and of interlocking pebbles that fit together and were then difficult to prise apart. A fibreglass cast was made for Moore's retrospective in Florence in 1972, as the two-tonne bronze would have been too heavy for the chosen site (a terrace at Forte di Belvedere). In addition to its practical advantages, the white fibreglass offers a striking contrast to the bronzes on display at Perry Green (see p.71) .

Knife Edge Two Piece 1962–65 >

In several of Moore's later monumental bronzes there are echoes of the massive rock formations in the countryside around Leeds, such as Adel Rock, which the artist knew as a boy. The Foundation's cast of this sculpture is the artist's copy and is marked 0/3. Artist's copies form the core of the Foundation's collection. Two further casts are in public collections: one is in Queen Elizabeth Park, Vancouver; the other, belonging to the City of Westminster, is sited outside the Houses of Parliament and is often seen as a backdrop during filmed interviews with the press. An even larger but reversed-image version, *Mirror Knife Edge* (1977), was commissioned for the entrance to the new east wing of the National Gallery of Art, Washington DC, designed by I.M. Pei (see p.22).

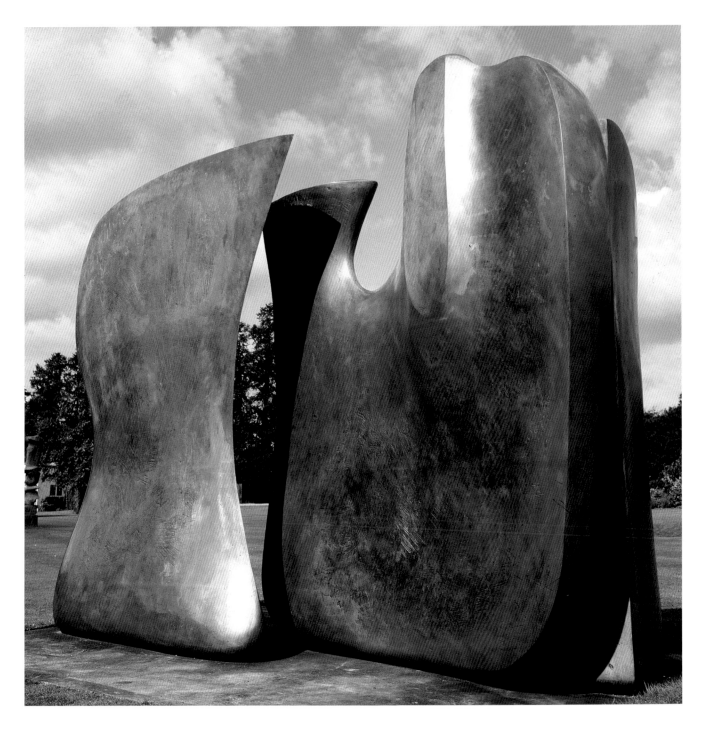

Double Oval 1966

Moore's interest in opening up form to create a
sense of mystery is here taken to its extreme; the
two elements of the sculpture have themselves
become apertures. The piece is monumental,
yet simple and graceful, the holes penetrating
the space between the two forms while at
the same time framing the landscape. As one
walks around the piece, the views through and
between the two forms are continually changing
and unexpected. One also has the impression
that the forms are emerging from the ground and
that what one sees is just the tip of an iceberg.

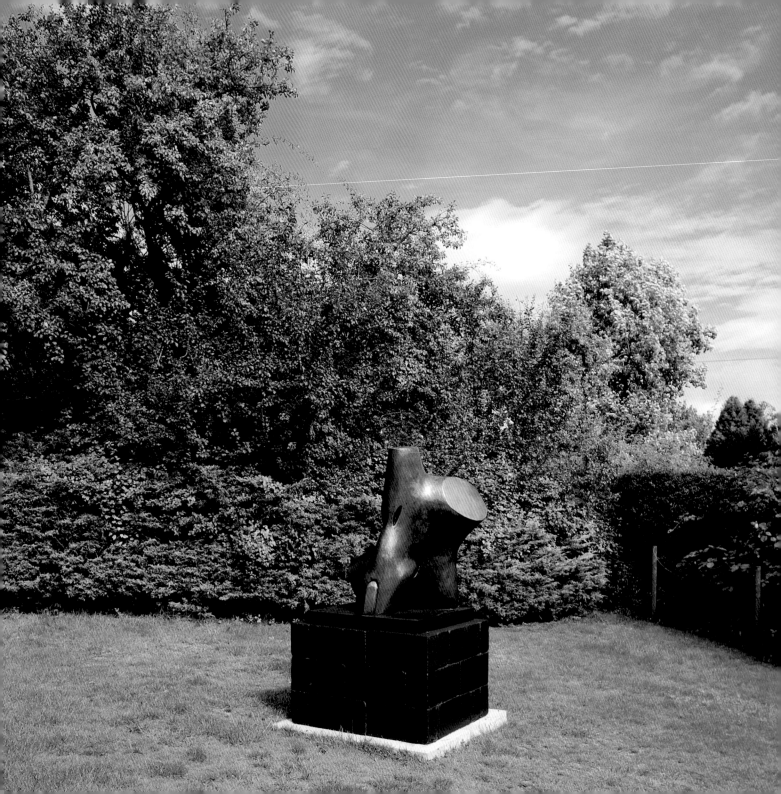

Torso 1967

Moore's comment that in his work he had the tendency to 'humanise everything, to relate mountains to people, tree trunks to the human body, pebbles to heads and figures' is illustrated particularly well by this sculpture, which combines elements of the human torso with the form of a tree trunk. Moore was fascinated by the trees that grew on the Perry Green estate, and some of the drawings that he made of their gnarled and twisted forms contain striking anthropomorphic elements. Although the head, arms and legs appear to have been hacked off like the branches of a tree, the form remains tense and firmly balanced, emphasising the importance of the torso as the centre of the human body. This was something that Moore explored in a number of other sculptures and drawings, commenting on one occasion that 'a torso fragment has a condensed meaning. It can stand for an entire figure...'

Working Model for Sundial 1965 >

This was sited by Moore in the garden at Hoglands in order to be visible from the large sitting room. The larger version of this work can be seen at the Adler Planetarium, Chicago, where it was installed in 1980. A second cast, originally commissioned for the offices of *The Times* newspaper, is now on public display in Brussels.

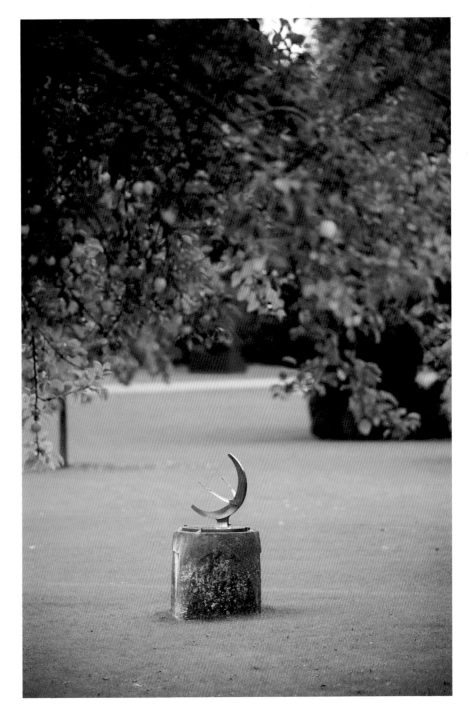

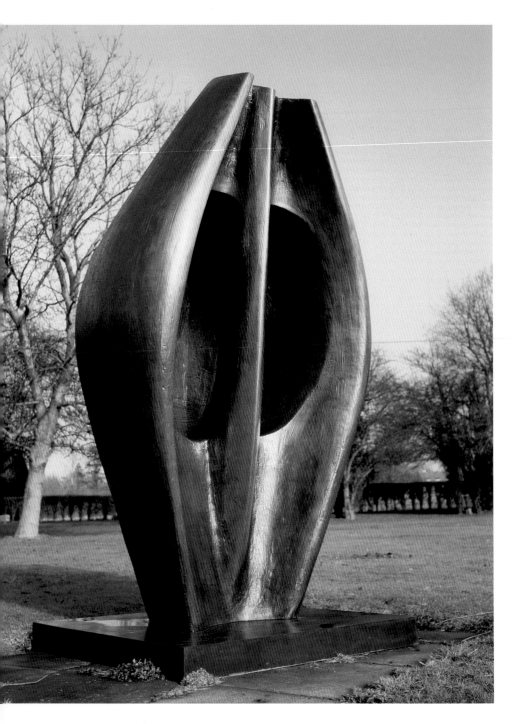

Large Totem Head 1968

This is a prime example of Moore's belief that in order to maintain interest, a sculpture should have a sense of mystery and not be read too quickly. Upon completion, a cast of this work was given by a German department store chain to the city of Nuremberg, where it was controversially received due to its sexual suggestiveness. But Moore refused to listen to psychoanalytic interpretations of his work. Reading a book on his work by a Jungian psychologist, Moore stopped after the first chapter because 'it explained too much about what my motives were and what things were about ... If I was psychoanalysed I might stop being a sculptor'. In the maquette for this work, made in 1963, the same form lies on its side and has the title *Head: Boat Form*. Moore felt that when enlarged and standing vertically, the sculpture evoked a huge impassive face with eyes.

Oval with Points 1968–70 >

This sculpture is one of many inspired by the elephant skull that can be seen in the Bourne Maquette Studio. Moore first saw the elephant skull in 1965 in the garden of his friends, Julian Huxley (then Director of London Zoo) and his wife Juliette. The couple subsequently gave the skull to Moore as a gift, and he was struck by the amazing depths and caverns of space, the strength of the bone in contrast to its fine edges and the tension created by the pointed forms almost touching. Pointing and touching themes are common in Moore's later work.

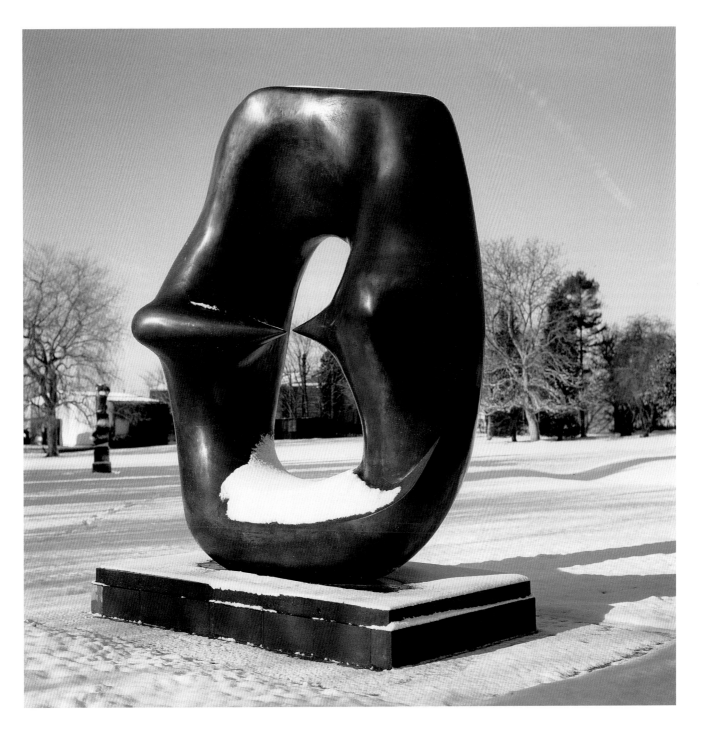

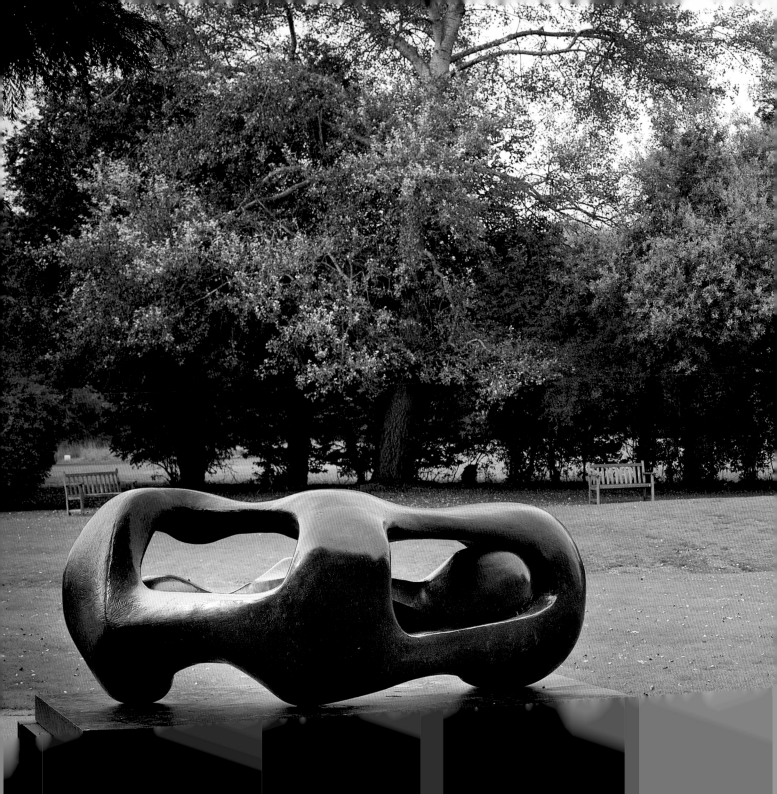

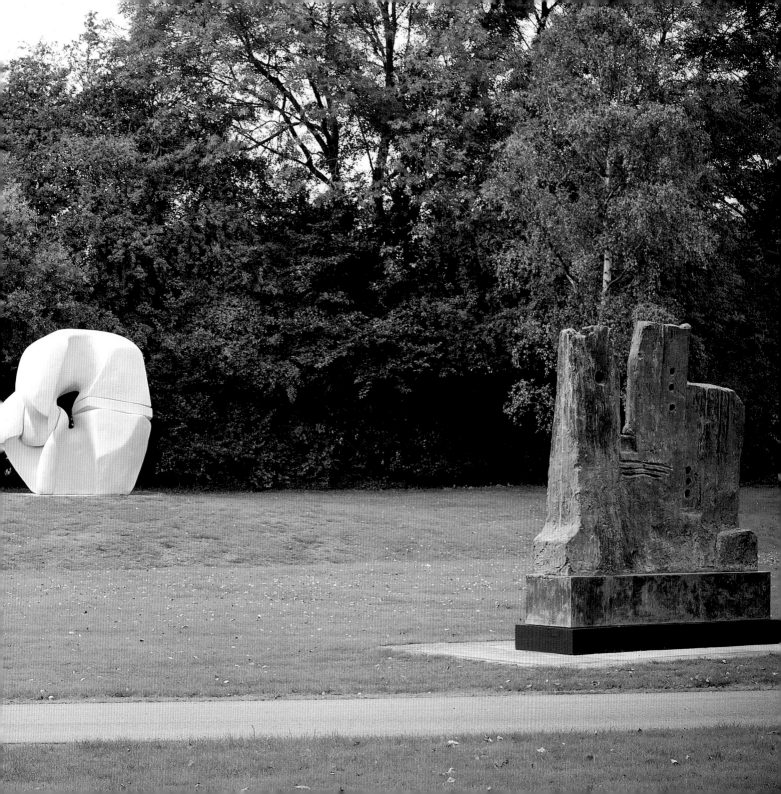

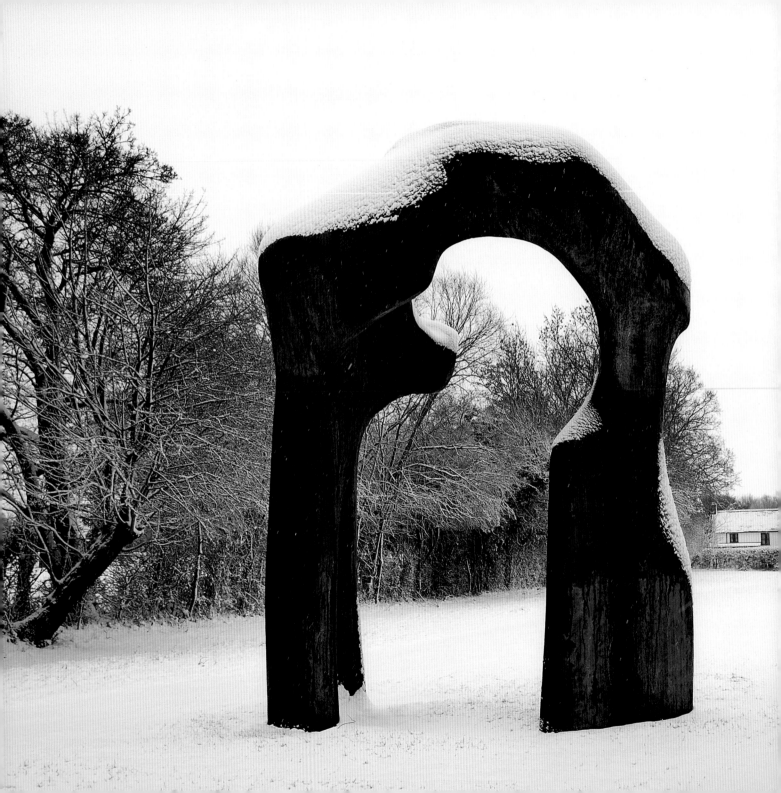

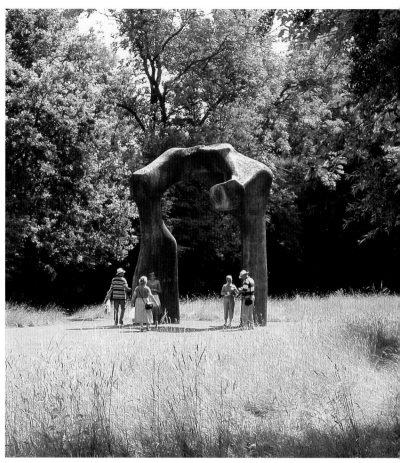

The Arch 1963–69

Enlarged from a maquette only a few inches high (on display in the Bourne Maquette Studio), *The Arch* is one of the grandest examples of all Moore's public sculptures, recalling the triumphal arches of antiquity. The original inspiration came from a fragment of bone. Concerned that sculpture should have a sense of monumentality and energy without appearing merely big and heavy, Moore commented: 'I would like to think my sculpture has a force, a strength, a life, a vitality from inside it, so that you have the sense that the form is pressing from inside trying to burst or trying to give strength from inside itself ... this is, perhaps, what interested me most in bones as much as in flesh because the bone is the inner structure of all living form'. A version of *The Arch* in travertine marble was presented to Kensington Gardens in 1980, following Moore's exhibition there and at the Serpentine Gallery in 1978.

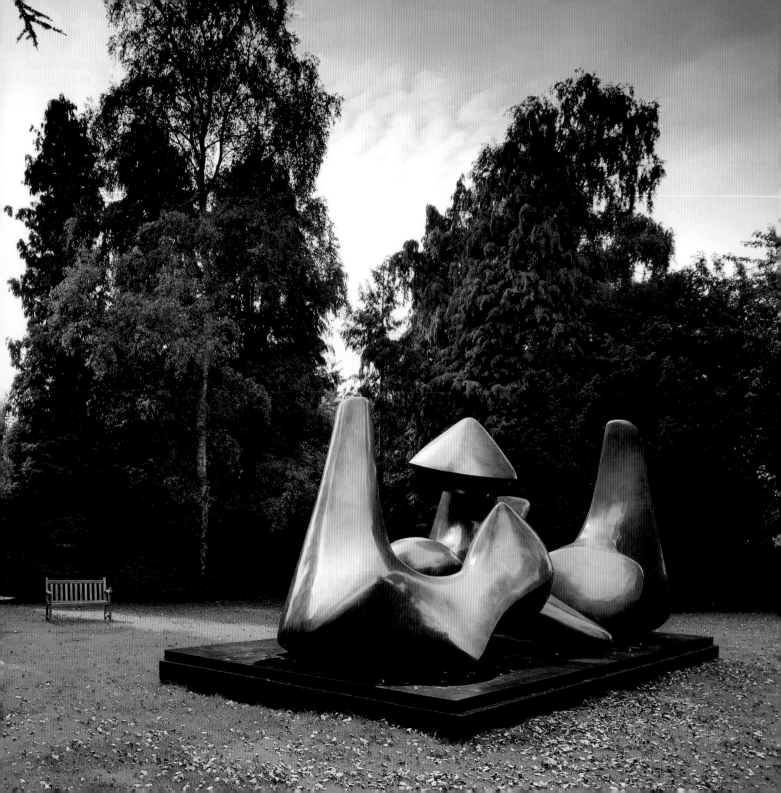

Three Piece Sculpture: Vertebrae 1968

In this work, enlarged from a hand-size maquette, what interested Moore was the idea of a progression of similar forms, like the joins between vertebrae. The three pieces can be placed well apart from one another so that the intervening spaces can be 'inhabited' or walked through by the viewer. Sculpture has one great advantage over painting, which is that it can be looked at from all round; and Moore's most successful works provide continual surprise and interest. This sculpture has a lacquered surface, which gives the work a warm golden colour and a degree of protection from the elements. Although the forms are organic, the vertebrae have been enlarged to such an extent that the result is abstract. Moore wrote: 'All art is abstract in one sense. Not to like abstract qualities or not to like reality is to misunderstand what sculpture and art is all about ... I see no reason why realistic art and purely abstract art can't exist in the world side by side at the same time, even in one artist at the same time.'

Large Spindle Piece 1974 >

This huge bronze belongs to a group of works from the late 1960s and early 1970s that combine anthropomorphic elements with organic forms, resulting in an amalgam of abstract and human associations. The immediately representational has gone, and with it the need for figurative supports such as seats, blocks, benches and pedestals. For Moore, a true appreciation of three-dimensional form came from thinking about sculpture from the middle outwards, rather than as a series of surfaces and outlines. The latent dynamism of this bronze and the sense that the form

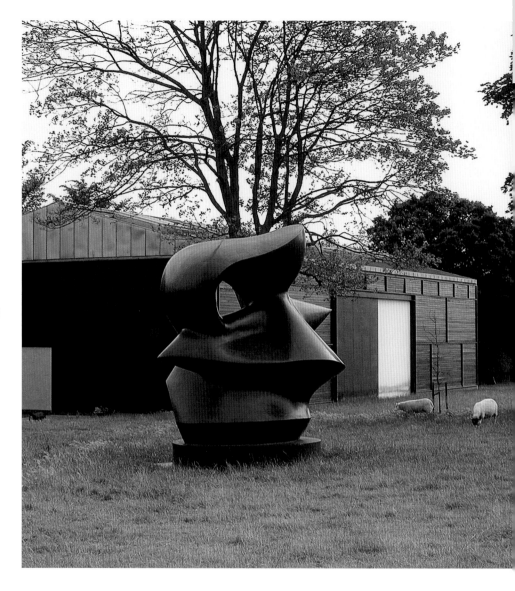

is bursting out from within remind us of the sculptor's comment that 'Force, power, is made by forms straining or pressing from inside. Knees, elbows, foreheads, knuckles, all seek to press outwards. Hardness, projection outwards, gives tension, force and vitality.' The origin of this piece was a small flint with thrusting points on either side. From this Moore made a cast in clay and then modelled the plaster maquette. It is one of very few works by him that exist in four sizes: maquette, working model, monumental bronze and a carved interpretation in travertine marble over 4.5 metres high, located in a hotel in Miami, Florida.

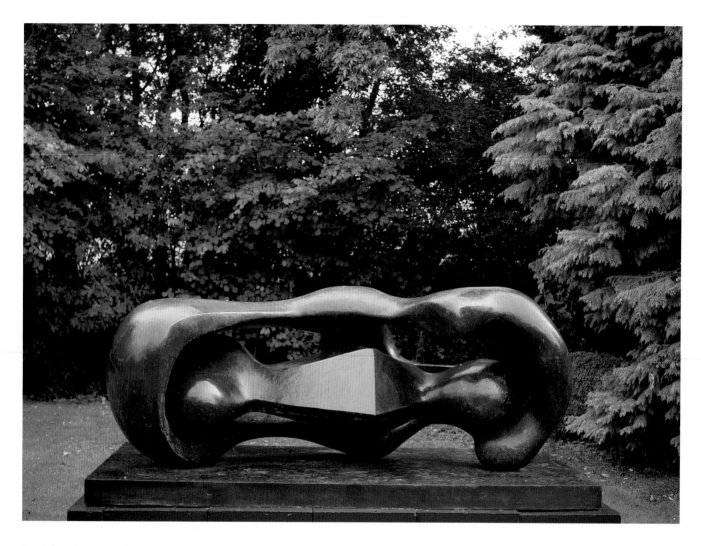

Reclining Connected Forms 1969

This sculpture continues Moore's exploration of internal-external forms, referring back to his helmet head series of the previous decade and anticipating later works such as *Large Figure in a Shelter* (p.92). In these pieces, an outer form protects or encloses an internal one. Moore looked to arms and armour (particularly in the Wallace Collection, London), as well as natural objects such as sea shells for inspiration. The internal-external concept also relates closely to more figurative works such as the mother and child.

Reclining Figure: Arch Leg 1969–70 >

The theme of the reclining figure was one of the most important in Moore's work and one to which he returned throughout his life. He compared it to Cézanne's 'Bathers' series: a set theme which liberated the artist to try out formal ideas. In later examples, he increasingly divided the reclining figure into two or three parts to realise in full the relationship between form and space. Here, the 'negative' space between the two smooth, truncated forms plays a significant role in experiencing the sculpture, creating a visual ravine through the centre of the work that affirms its affinity with the landscape.

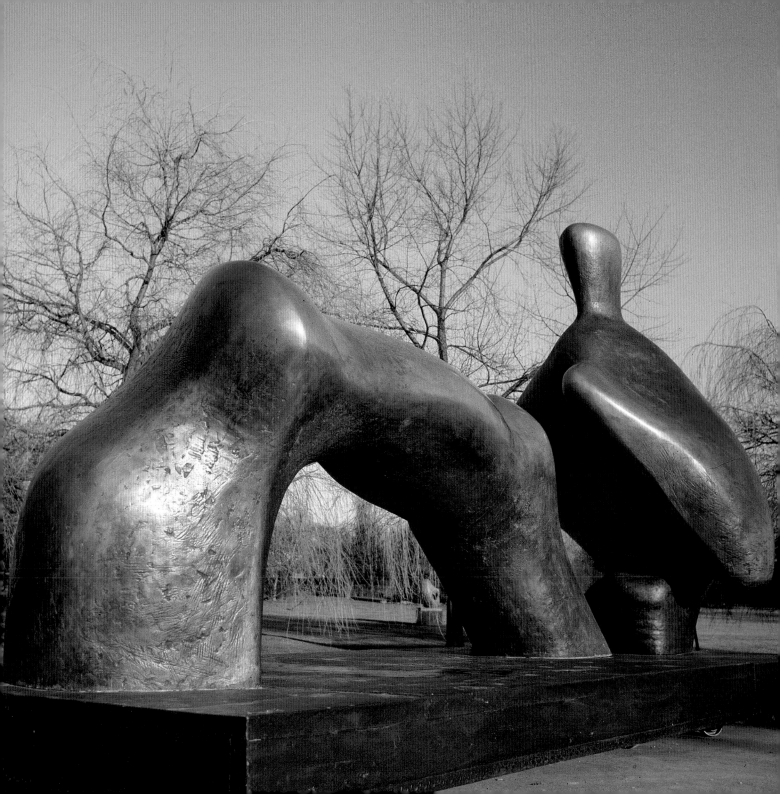

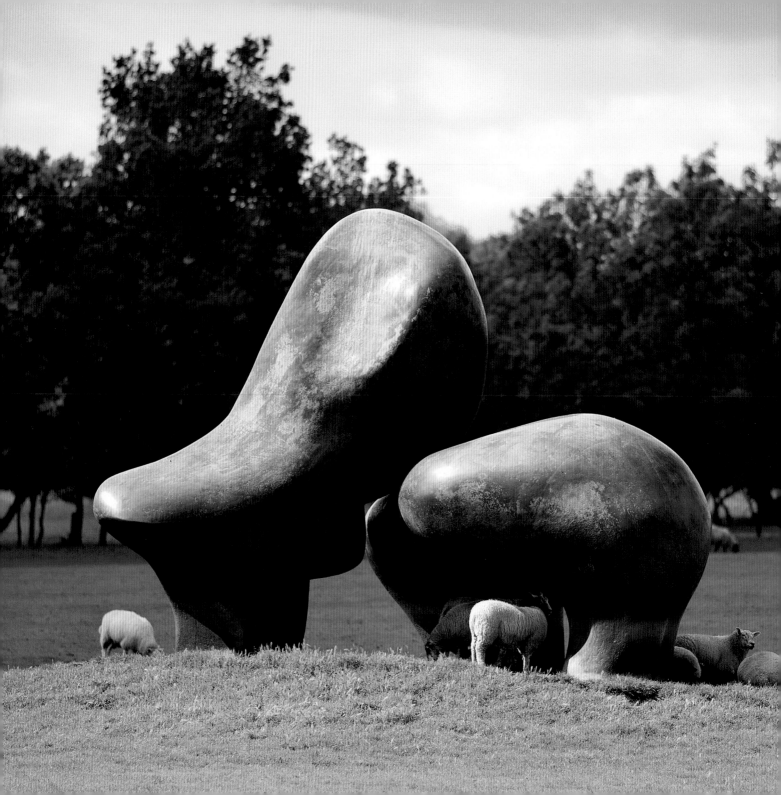

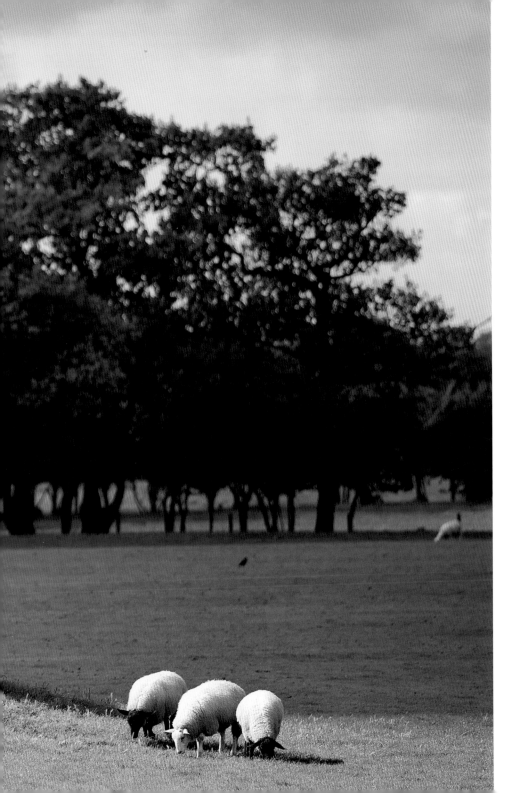

Sheep Piece 1971–72

This work demonstrates Moore's interest in the relationship between two forms, their closeness creating a sense of both tension and intimacy. The sculpture was first displayed in Kensington Gardens for an exhibition at the Serpentine Gallery in 1978, after which Moore sited it in the sheep field where it can still be seen today. The sheep field is rented to a local farmer, thus retaining within the surrounding landscape the animals that Moore admired. In the 1980 publication of his *Sheep Sketchbook*, Moore describes how his initial perception of the sheep which grazed outside his studio as 'rather shapeless balls of wool with a head and four legs' gave way to an increased understanding of their form as he observed that 'underneath all that wool was a body, which moved in its own way'. The sight of the ewes and lambs together, the larger forms in relation to smaller ones, evoked one of his favourite themes, that of the mother and child. He commented that sheep were 'just the right size for the kind of landscape setting that I like for my sculptures', as opposed to cows or horses whose larger size would reduce the sense of monumentality in his work.

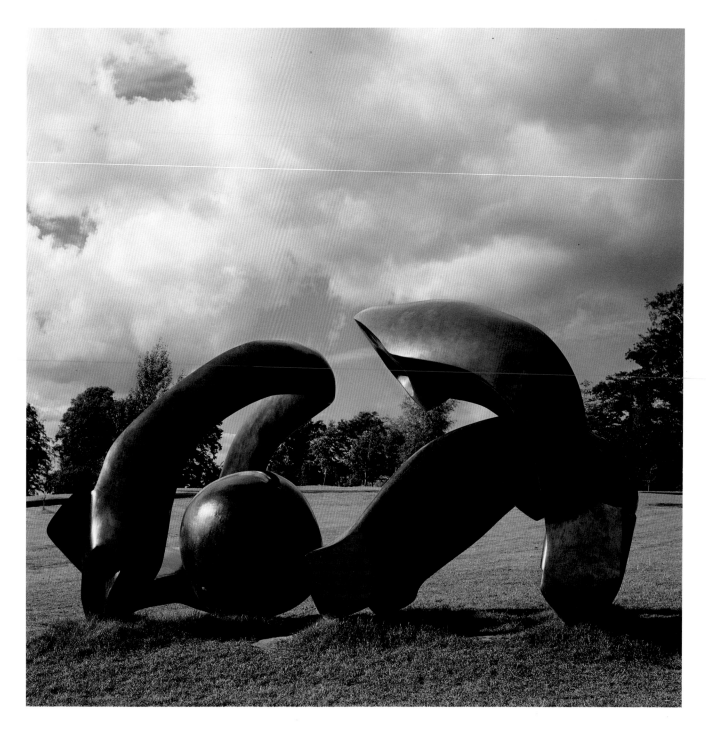

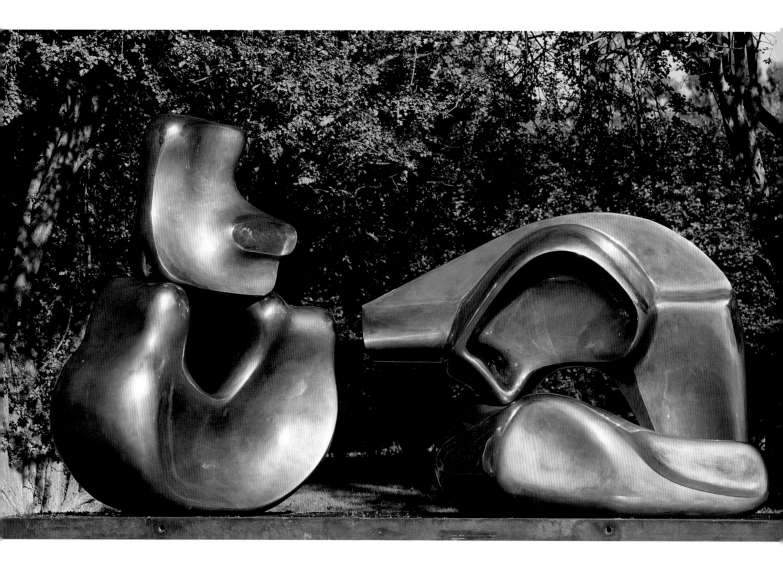

< Hill Arches 1973

'A Baroque sculpture for a Baroque church' was Moore's comment when a cast of this large, majestic bronze was sited in a reflecting pool in front of the Karlskirche in Vienna in 1973. The artist was referring to the complex and strong diagonals balanced by a circular form. Equally at home in the landscape, the Foundation's cast is often sited in the fields of the Yorkshire Sculpture Park, which Moore helped to found in the late 1970s. The plaster maquette, only 11 cm long, can often be found in the Bourne Maquette Studio.

Large Four Piece Reclining Figure 1972–73

In the early 1970s, Moore produced a group of monumental sculptures relying heavily on the curve or arc as its principal motif. This work, in the company of *Sheep Piece* and *Hill Arches*, exemplifies the trend. The hollows, voids and truncated elements bind together very successfully to make a sculpture filled with warmth and movement.

81

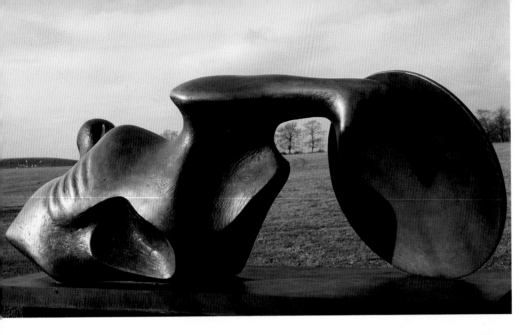

Goslar Warrior 1973–74

Moore rarely depicted the male form. This warrior figure recalls both the subject matter and heroic quality of Greek sculpture, at the same time suggesting the fragility of man. Here the defeated warrior has fallen; he is unarmed, and has (as Moore described of a related warrior sculpture), 'a bull or dumb animal acceptance and forbearance of pain'. This psychological state is heightened by the elimination of the figure's limbs with the exception of the one leg propping up the defunct shield.

This sculpture was being cast by the Noack Foundry in Berlin when Moore heard that he had been awarded a prestigious art prize by the town of Goslar in Germany. With the prize came a commission for a work to be sited prominently in Goslar itself; Moore decided to change the name of the sculpture to *Goslar Warrior* and to make a cast available to the town.

Three Piece Reclining Figure: Draped 1975 >

In its sweeping curves and bold elisions, this work shows to what degree Moore had simplified his sculptural language since the first three-piece reclining figures of the early 1960s. As he himself said about the earlier series: 'You do things in which you eliminate something which is perhaps essential, but to learn how essential it is you leave it out. The space then becomes very significant.' Echoing the forms and rhythms of landscape, the figure contrasts roughly textured areas with smooth, polished ones. The sharply blunted surfaces of the face and torso emphasise the monumentality of the figure as a whole, lending it a tough yet elegant quality.

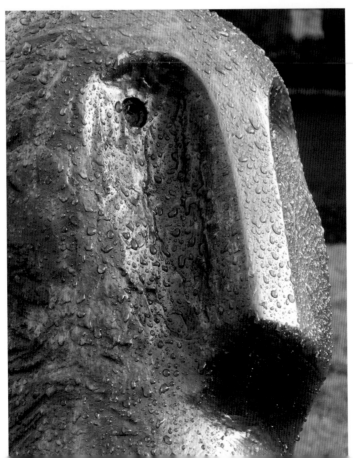

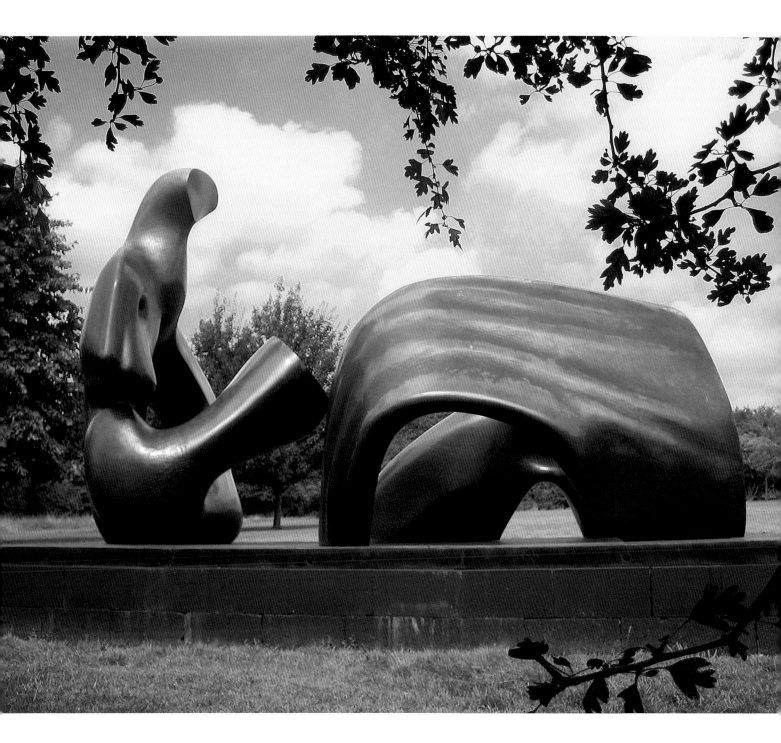

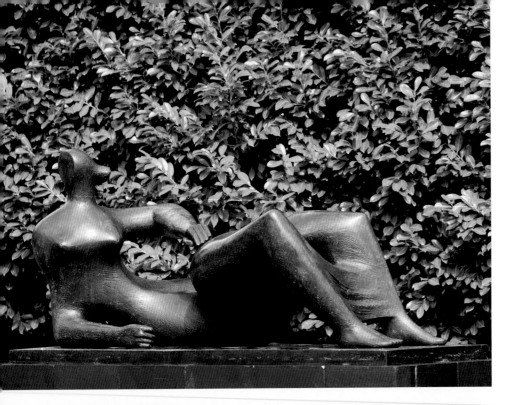

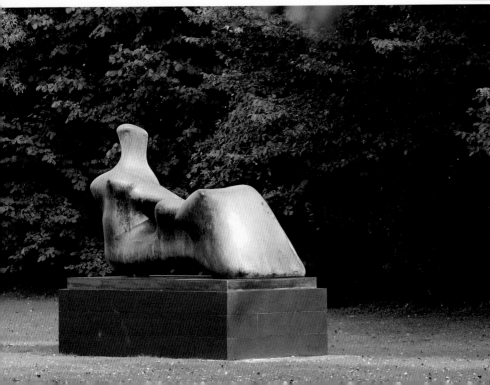

Reclining Figure 1982

Moore's fascination with the reclining figure lasted from the early 1920s until the end of his life. He described the Mexican reclining figure of the *Chac-Mool* that he saw on visits to the British Museum as one of the most important influences on his early work, commenting that it was not only the reclining pose of the figure but its sense of weight and massiveness that appealed to him. Although this sculpture, made when Moore was 84, has a more elongated, sinuous quality than some of his earlier sculptural explorations of the theme, traces of the Mexican influence can still be found in the majestic turn of the woman's head and the solid weight of her legs.

Reclining Figure: Hand 1979

The inspiration for this work came from some bits of flint and bone which Moore found in the grounds of Hoglands. He then constructed a plasticine, bone and flint maquette from the found objects. The result is a sculpture that both derives from nature and ultimately relates to the land in a much broader sense. Moore explained: 'In my reclining figures I have often made a sort of looming leg – the top leg in the sculpture projecting over the lower leg which gives a sense of thrust and power – as a large branch of a tree might move outwards from the main limb – or as a seaside cliff might overhang from below if you are on the beach.'

Reclining Figure: Angles 1979 >

There are casts of this sculpture in the Hakone Open Air Museum in Japan and the Art Gallery of New South Wales, Sydney. The Foundation's cast has travelled extensively throughout the world since its creation. This particular one is patinated brown but there are other casts within the edition which Moore coloured green. This is not unusual, and there are several editions of sculptures in Moore's oeuvre with greatly differing patinas.

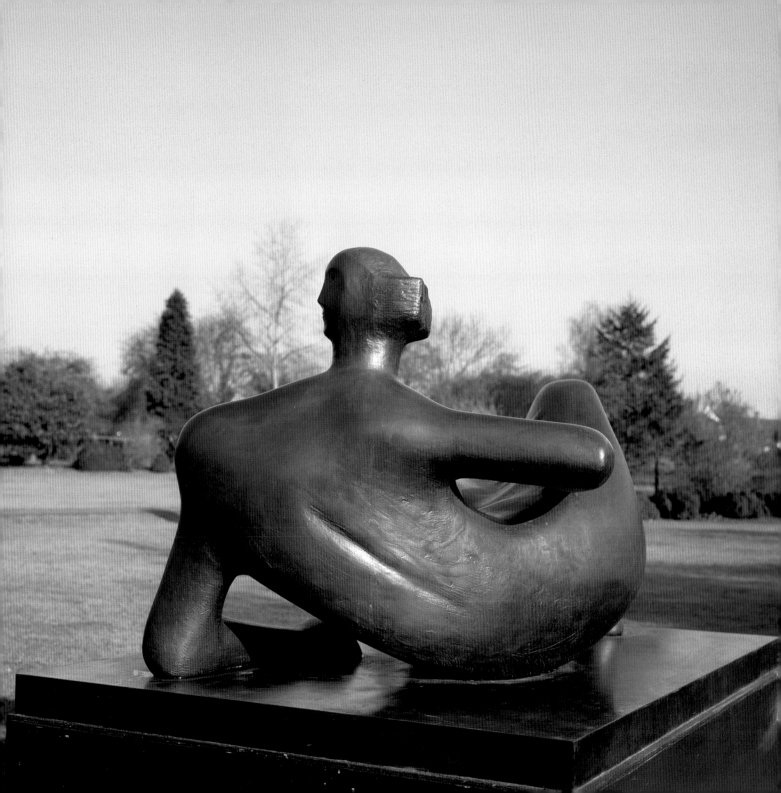

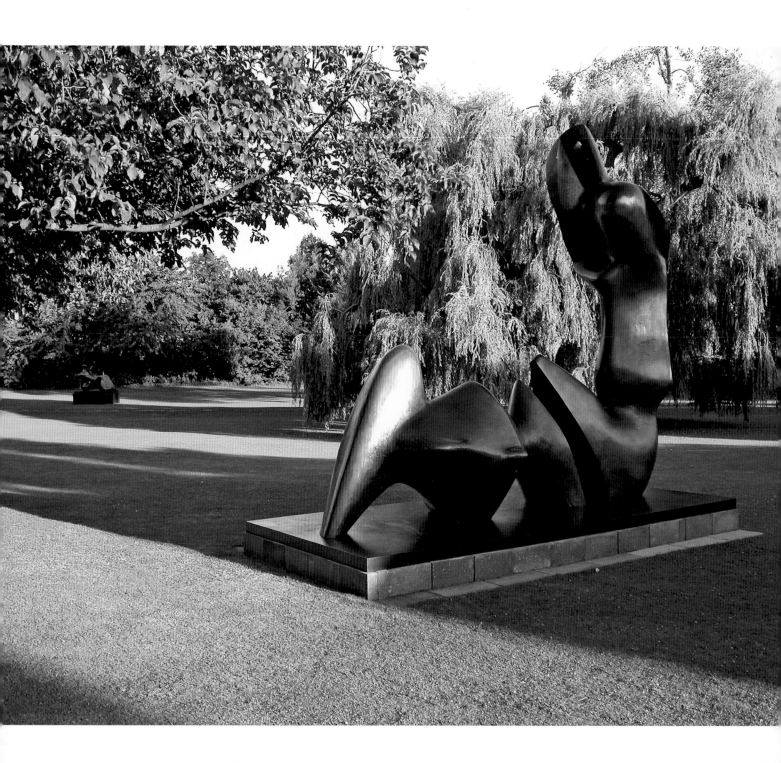

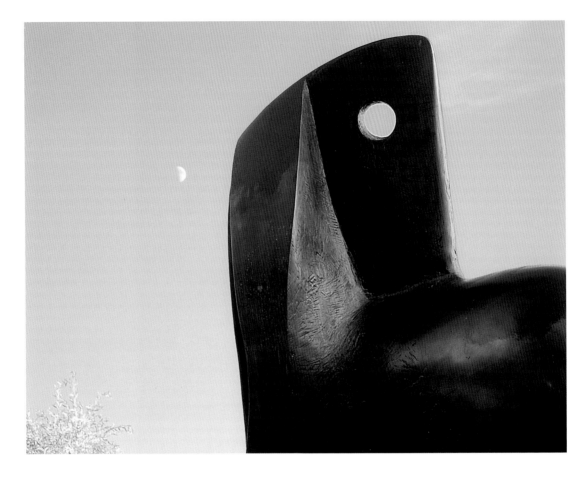

Two Piece Reclining Figure: Cut 1979–81

The sensual curves of this female figure are ruptured by
a deep incision – a stark slice through the body. Moving
around the split figure, one's gaze is drawn upwards to the
head, with its single eye framing a patch of sky. The origin of
this piece was a maquette, 20 cm high. Enlarged to 30 cm,
the piece was renamed *Architectural Prize*. Nine casts were
purchased and used by the Hyatt Foundation in Rosemont,
Illinois, as awards for the Pritzker Architecture Prize: an award
for living architects whose work consistently and significantly
contributed to humanity and the built environment. The
first recipient was Philip Johnson, a friend of Moore's. This
further enlargement was made in the late 1970s.

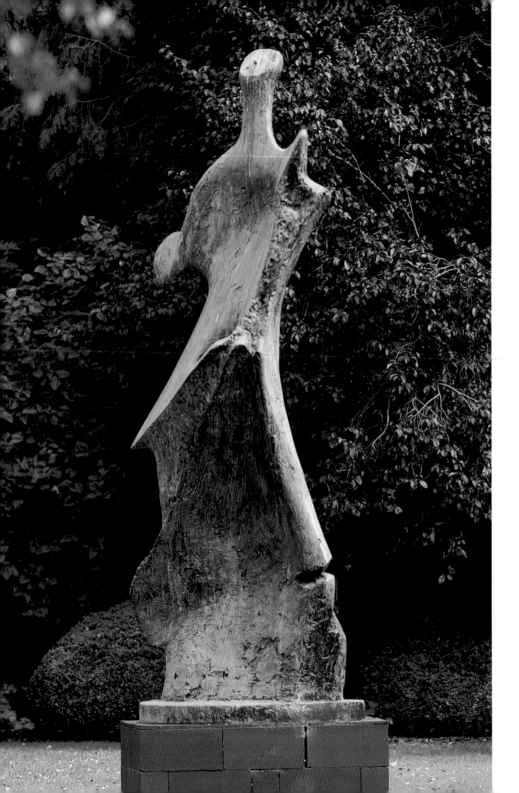

Large Standing Figure: Knife Edge 1976

This work is basically an enlarged bone with
very little alteration to the object's shape and
texture apart from the addition of a small head.
Moore had always been fascinated by bones
as objects: 'Since my student days I have liked
the shape of bones, and have drawn them,
studied them in the Natural History Museum,
found them on sea-shores and saved them out
of the stew pot... There are many structural
and sculptural principles to learn from bones,
e.g., that in spite of their lightness they have
great strength. Some bones, such as the breast
bones of birds, have the lightweight fineness of a
knife-blade.' The spirited grace of the figure has
been compared to the Greek *Nike of Samothrace*
in the Louvre.

Large Internal Form 1981–82 >

Recognisable as the internal element of *Large
Upright Internal/External Form* (p.52), Moore
cast this separately as a sculpture in 1981. It
gives force to the idea of the internal form as
a figure in its own right, as with *Large Figure in a
Shelter* (p.92), in which the figure was also cast
separately. Both derive from Moore's helmet
head series.

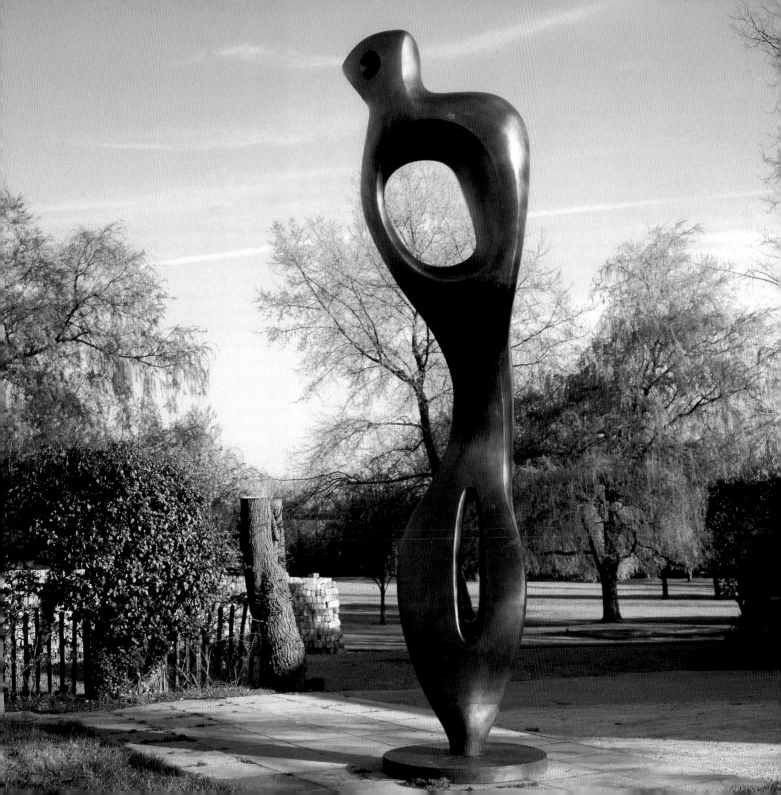

Draped Reclining Mother and Baby 1983
Completed when Moore was 85, this sculpture combines the three predominant themes to which the artist returned throughout his career – the reclining figure, the mother and child, and internal-external forms. It is also a synthesis of figure and landscape. The Foundation keeps much of the preparatory material for this work on display in the studios: the original tiny plaster can be seen in the Bourne Maquette Studio, and the bronze working model, with its plaster and various moulds, are in the Yellow Brick Studio. In the Plastic Studio are the full-size polystyrene model and the plaster from which the large bronzes were cast (see p.48).

Mother and Child: Block Seat 1983–84 >
Moore regarded the subject of the mother and child as a 'fundamental obsession'. Despite the monumental quality of the sculpture, there is a tenderness in the curve of the mother's body and arm. This idea of a protective outer form sheltering a more vulnerable element is also explored in Moore's numerous sculptures and drawings of the internal-external form. The work is also an example of Moore's experiments with seats, plinths and walls as an integral part of the sculpture.

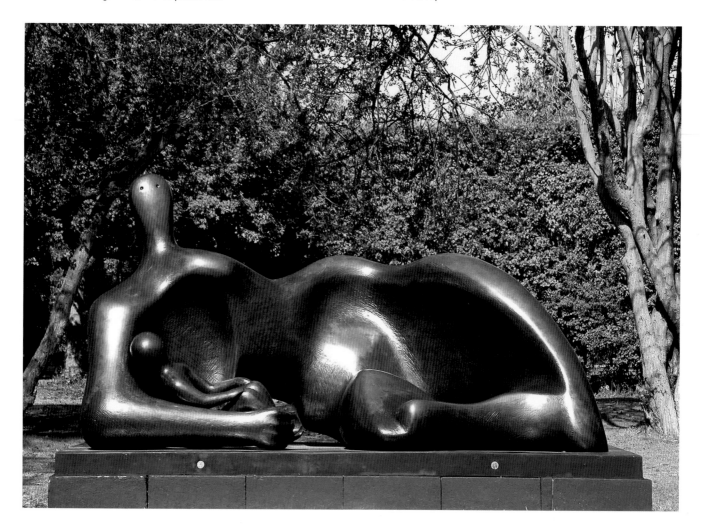

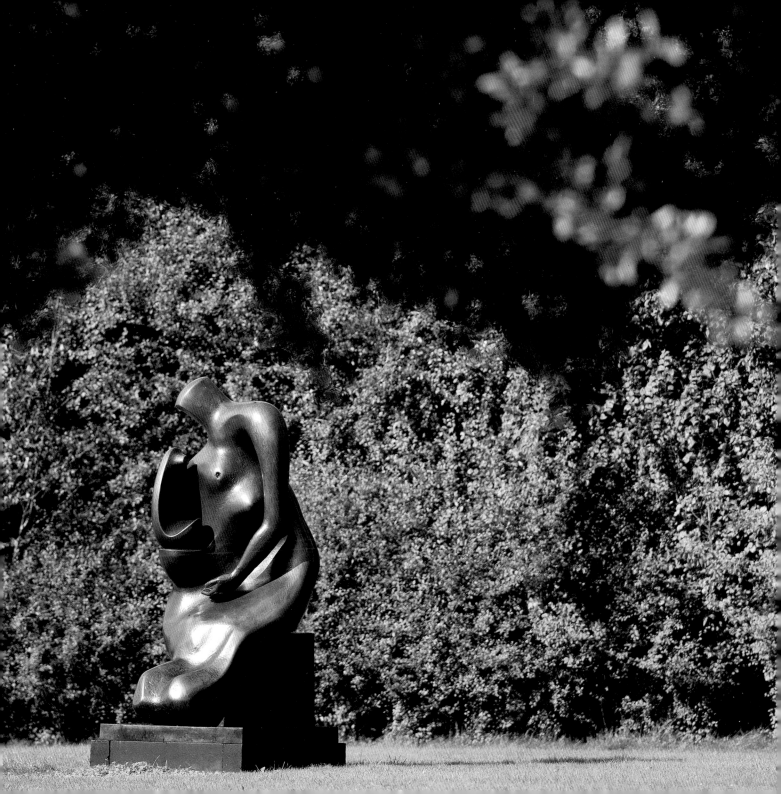

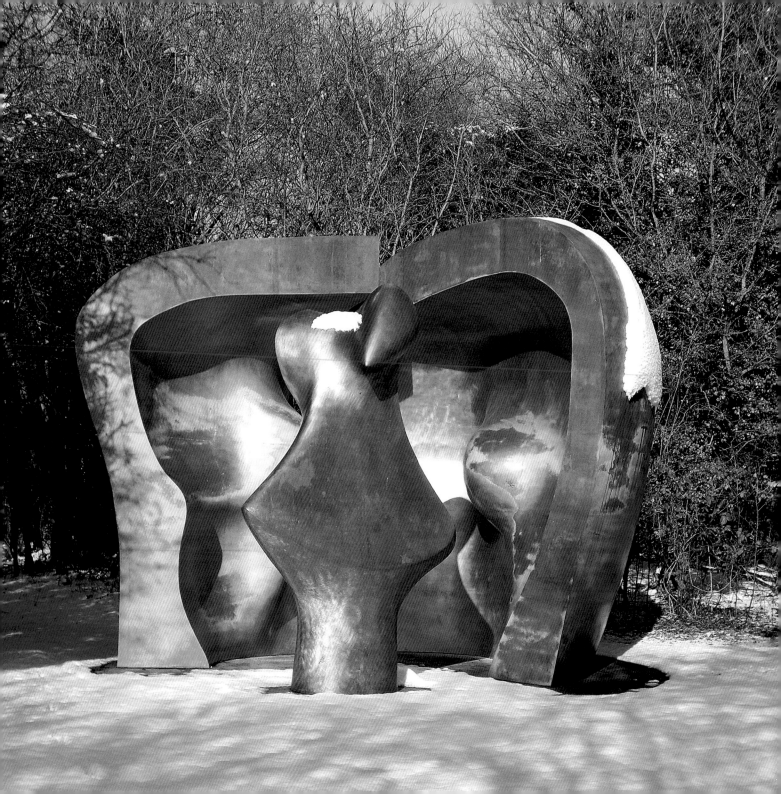

Large Figure in a Shelter 1985–86

Moore's last monumental bronze, this work relates to the
series of helmet heads and interior-exterior sculptures that the
artist returned to periodically from the late 1930s onwards.
It was much altered during each stage of enlargement; in
the original maquette the upright form is pushed far back
inside the 'helmet'. As the size of the work increased, Moore
brought the central form further forward to stand free of the
shelter, which itself was repositioned by being divided into
two unequal halves. The other cast of this work stands in the
Peace Park in Guernica, Spain.

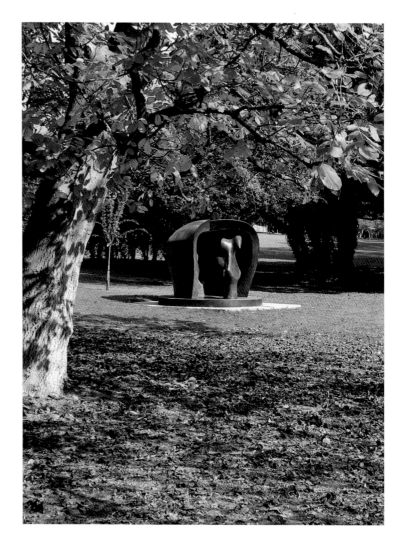

Figure in a Shelter 1983

Unlike the much larger version made at the end of Moore's
life, the 'shelter' of this earlier piece is formed of one section in
keeping with its original conception, seen in a maquette of 1975.
The flat cylindrical base, an integral part of the work rather than a
mere plinth, and a mysterious deep green patina also set it apart.
One of an edition of six, this cast stood for many years in the
gardens of the Prime Minister's country residence at Chequers
in Buckinghamshire, where it was greatly admired by visiting
dignitaries.

Large Reclining Figure 1984

Talking about the landscape on which this sculpture sits, Moore said: 'When I acquired the ground it was a pyramid of waste gravel. But you cannot put a sculpture on a pyramid if the point is too small, so I had a bulldozer shape it into a small hill (sometimes mistaken for a pre-historic barrow).' *Large Reclining Figure* was enlarged from a small lead reclining figure of the late 1930s but was not placed on the hillock until after Moore's death. The piece is remarkably effective as a silhouette against the sky – Moore's favourite background for sculpture. It is one of two casts; the other is sited outside the Overseas Chinese Bank Headquarters in Singapore, designed by I.M. Pei – the fourth and final commission on which Moore and the distinguished Chinese-born architect collaborated. The Foundation also owns a version in fibreglass which it lends to exhibitions of Moore's work throughout the world.

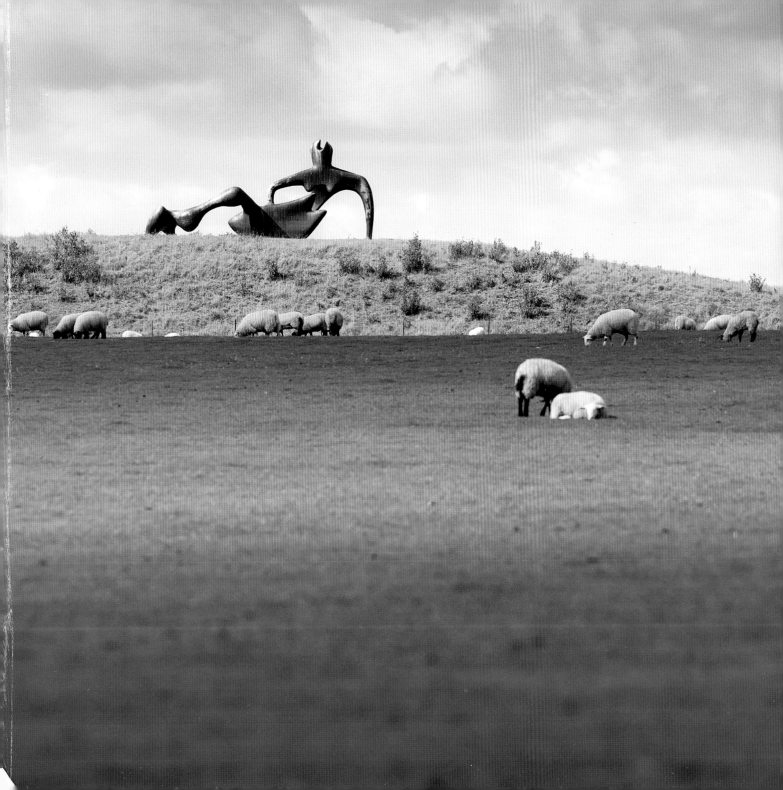

LIST OF WORKS

Details of the sculptures illustrated in the *Henry Moore: Sculptures* chapter are listed below in the order in which they appear. LH numbers refer to the six-volume catalogue raisonné of Moore's sculptures published between 1944 and 1994 by Lund Humphries, London.